D1135034

FLOWER PORTRAITS

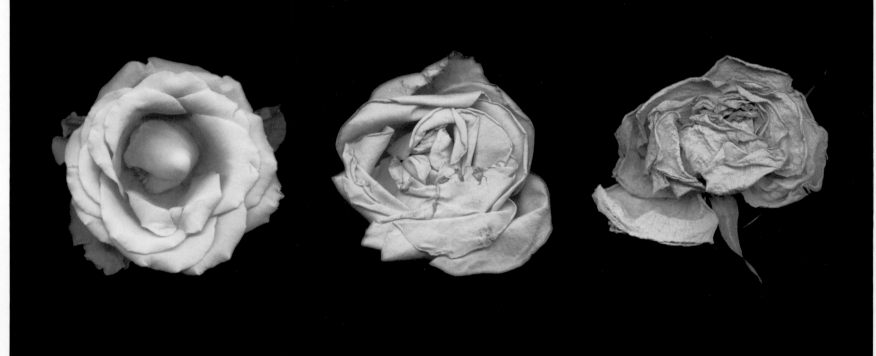

JOYCE TENNESON

FLOWER PORTRAITS

THE LIFE CYCLE OF BEAUTY

BULFINCH PRESS

AOL Time Warner Book Group

BOSTON • NEW YORK • LONDON

First Edition

ISBN 0-8212-2853-6

Library of Congress Control Number 2002116272

Bulfinch Press is a division of AOL Time Warner Book Group.

Tritone separations by Martin Senn
Designed by Miwa Nishio

PRINTED IN ITALY

To all the talented young assistants who not only have contributed to this book but have enriched my life in untold ways...

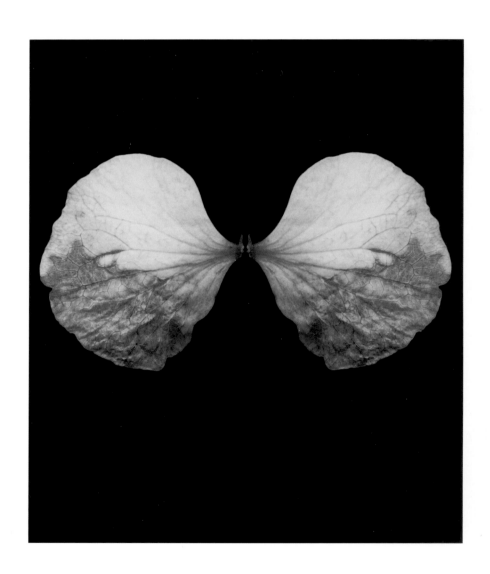

INTRODUCTION

The mystery and evocative power of flowers have been a secret world I have always wanted to penetrate. As a portrait photographer, I see flowers not as mere decorations, but as distinct personalities. Before I do human portraits, I try to learn as much as I can about my subjects, so when I begin the photo session, I have a sense of their history. I try to open myself to their universe — to discover some inner essence that helps crystallize their uniqueness. I photograph flowers with the same respect.

In my last book, *Wise Women*, I focused on photographing women in the third phase of their life. I had no idea what I would uncover when I embarked on that journey. After interviewing and photographing more than three hundred subjects, I was overwhelmed by what I found. Rather than the negative stereotypes that our culture has fostered, I found these women to be often more radiant, beautiful, and exquisitely individual than ever before. The response to *Wise Women* has been richly gratifying to me. It is as if I had helped unearth a treasure that people, including myself, had been unaware of before.

As a way of refreshing myself after such a consuming project, I went back to photographing flowers. I had been drawn to this subject often between my other book projects, all of which had involved photographing people. However, just as my awareness had been alerted and changed by the beauty of human aging, so my approach to photographing flowers changed as well this time around. I was no longer only interested in the perfect bloom: the moment, often ephemeral, of youth. I became mesmerized by how each flower changes over time, and is often equally beautiful as it completes the inevitable life cycle of birth, blossoming, and seeming decline. I attempted in this series of flower portraits to convey my own excitement at the discovery of this rich visual metamorphosis. I photographed each flower throughout the entire life cycle. What I found amazed me. I woke up each day filled with curiosity for this whole mysterious universe. By carefully preserving the flowers, I was able to observe and photograph them over time. Flowers remind us of the interconnectedness of all life. Through observing my subjects, I saw wisdom and beauty with new eyes.

The ephemeral nature of flowers has often been used as a metaphor for the human condition. In the myths of every culture we see that nothing remains constant. Aging, ripeness, and death are all parts of life — different exhalations along the labyrinth of existence. In his hauntingly beautiful description of the death of a friend's baby daughter, John Milton writes:

> O fairest flower no sooner blown but blasted;
> Soft, silken, primrose fading timelessly

It's much rarer, though, to find flowers compared to people and to see them endowed with the personality and magnetism they deserve. If instead of mourning the passing of time, we focused on the beauty of each moment within that passing, we might learn new things — the personality in each blossom, for instance, the unique expression in the face of each flower, at every stage of its journey. I hope you find the same secret delights and fascinating individuals in these flower portraits as I did. It has been an amazing voyage for me.

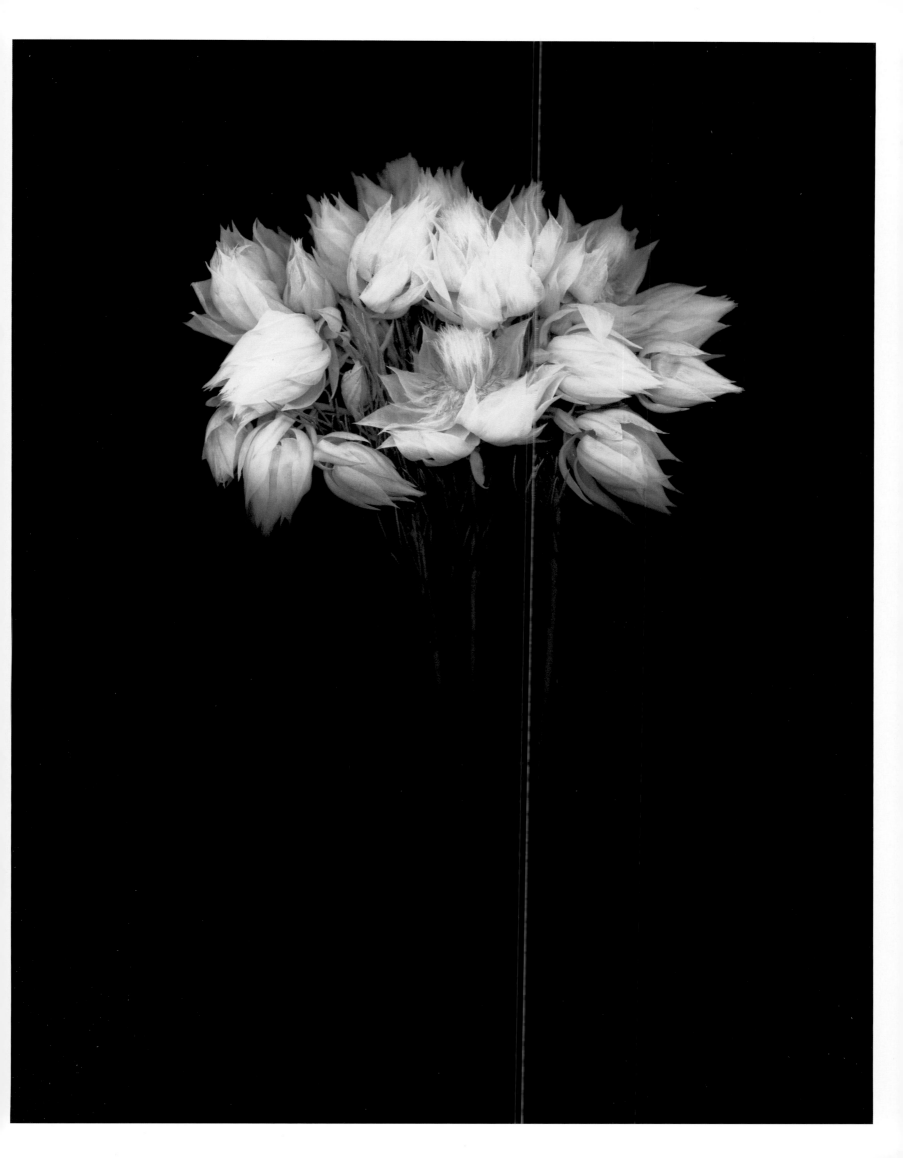

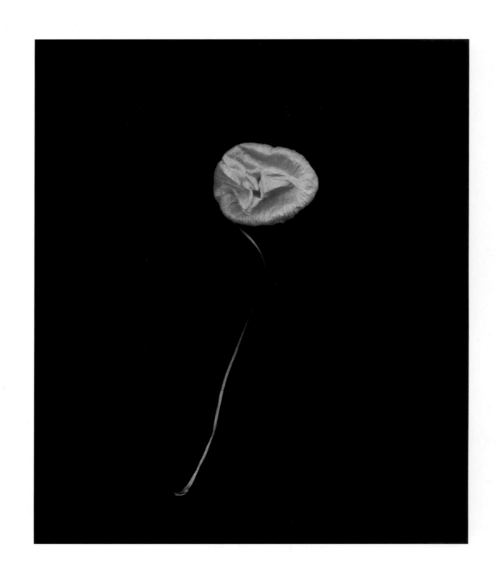

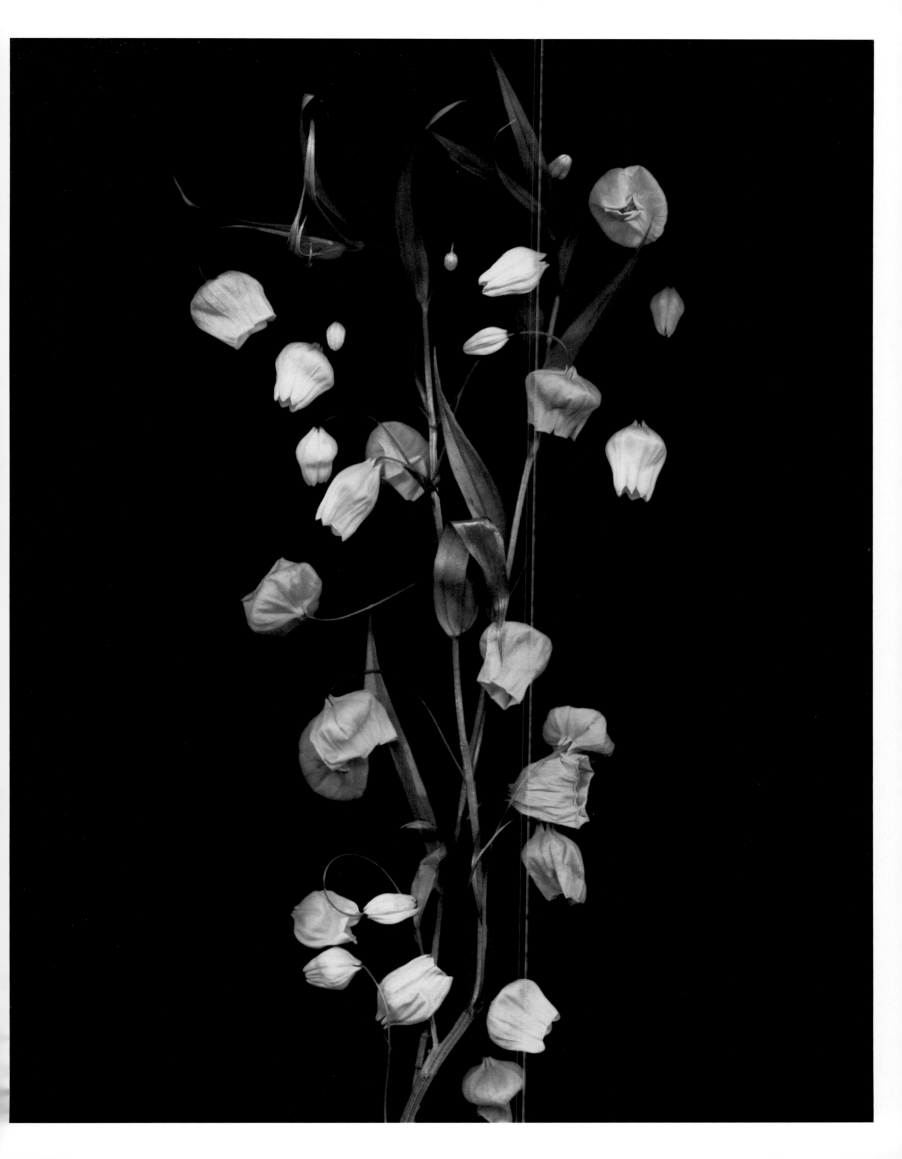

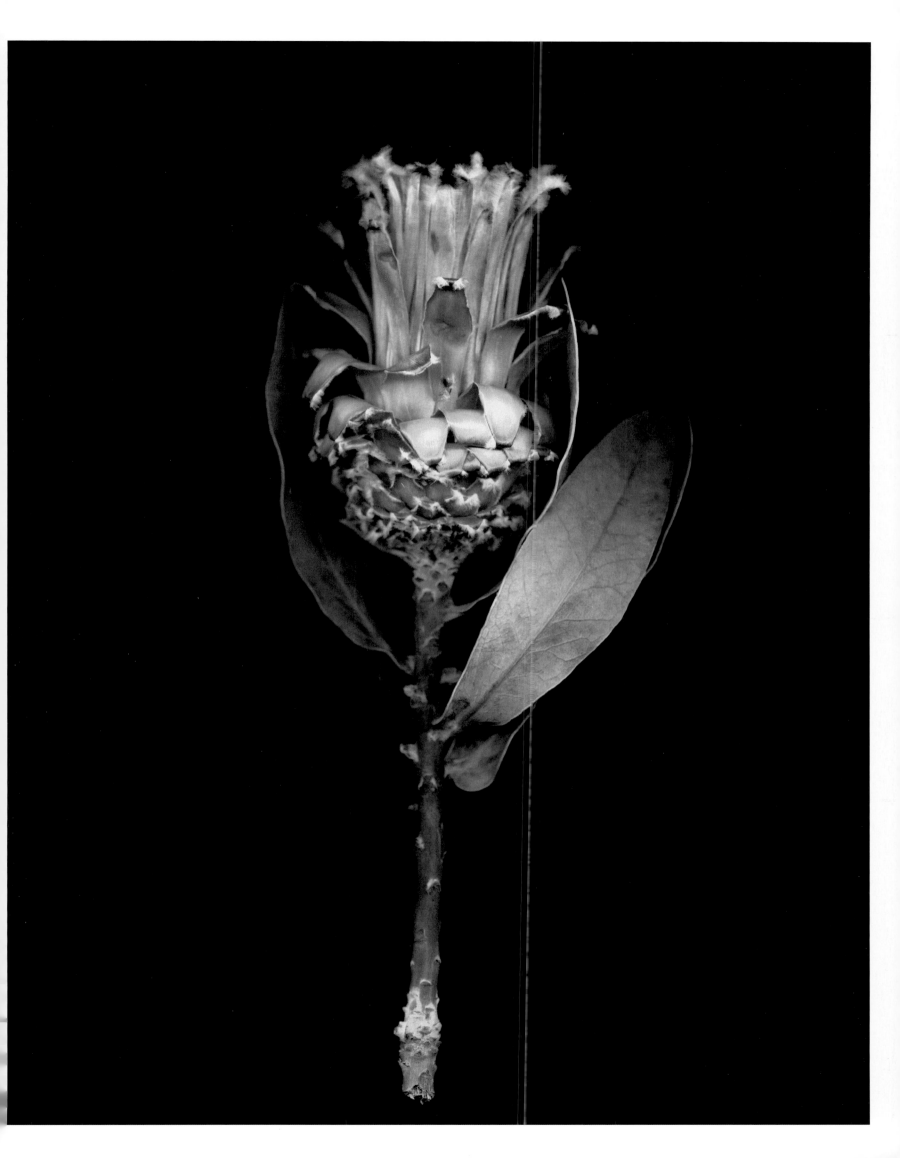

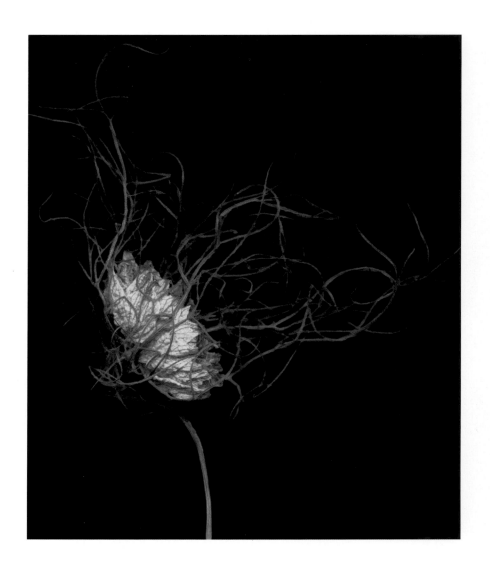

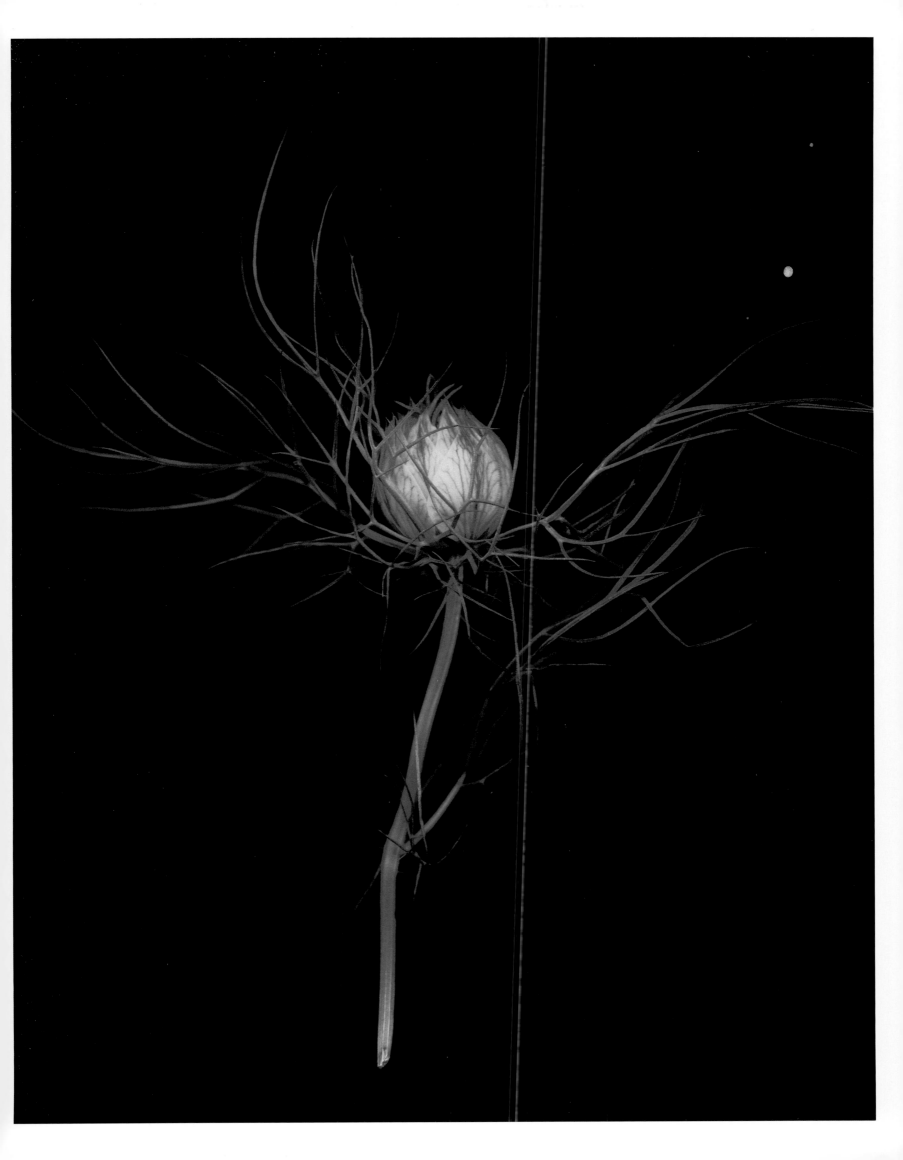

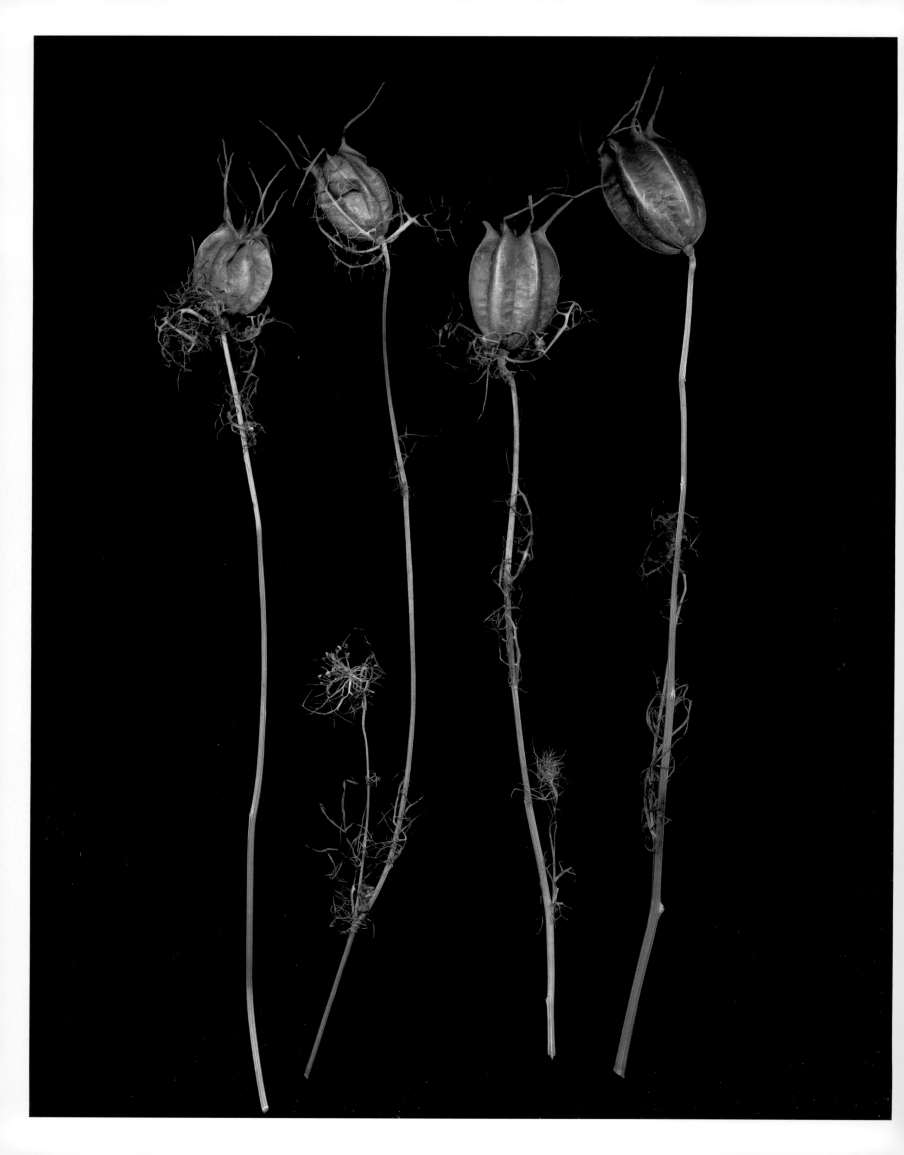

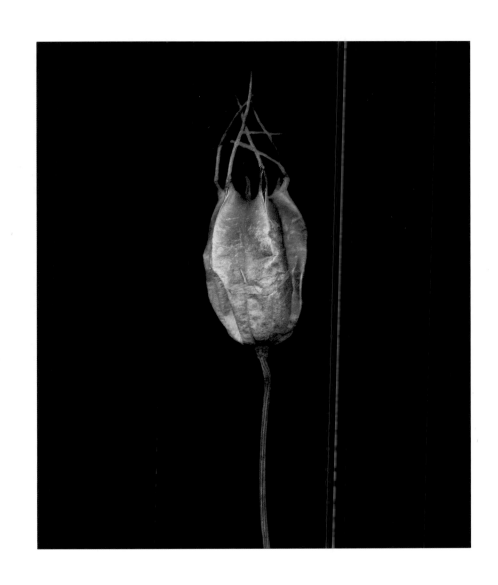

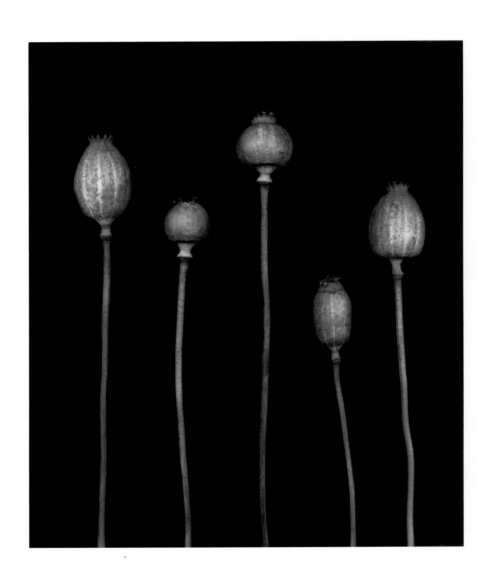

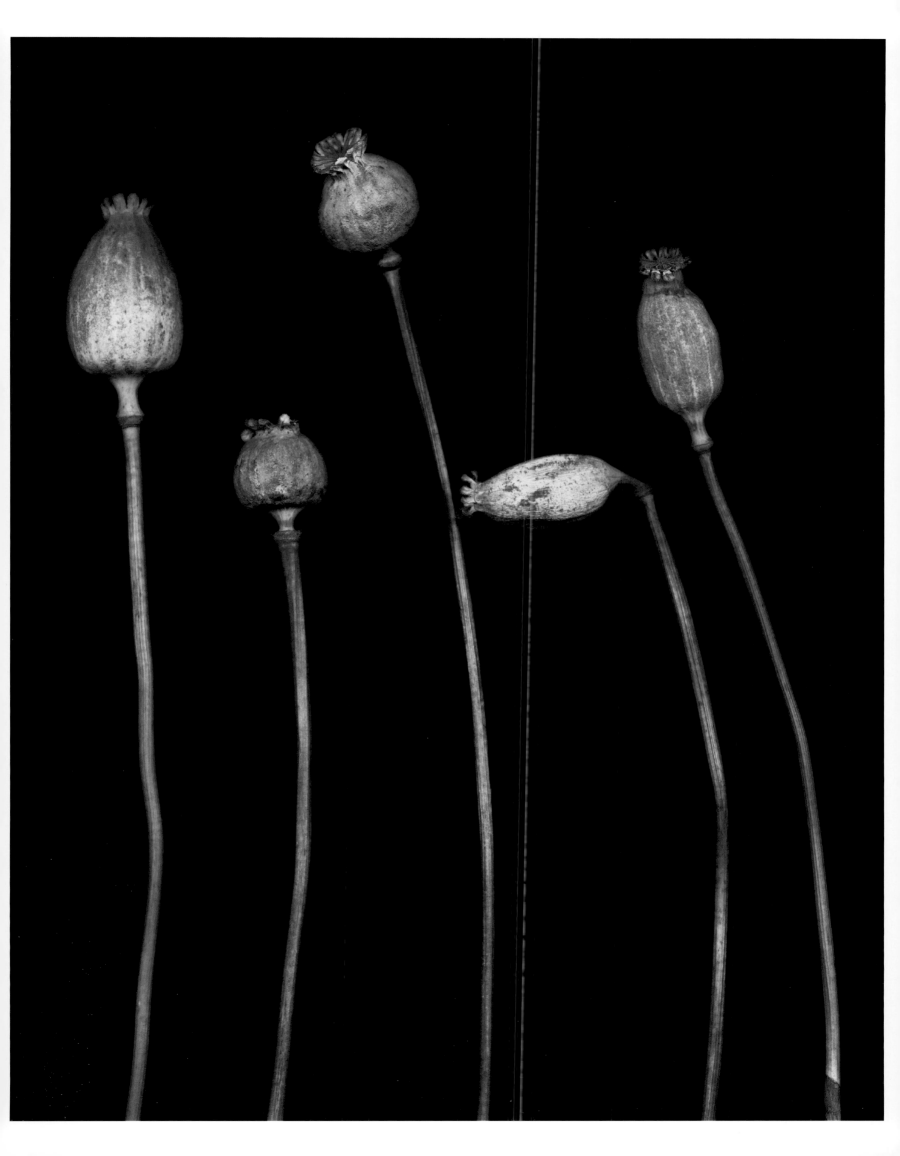

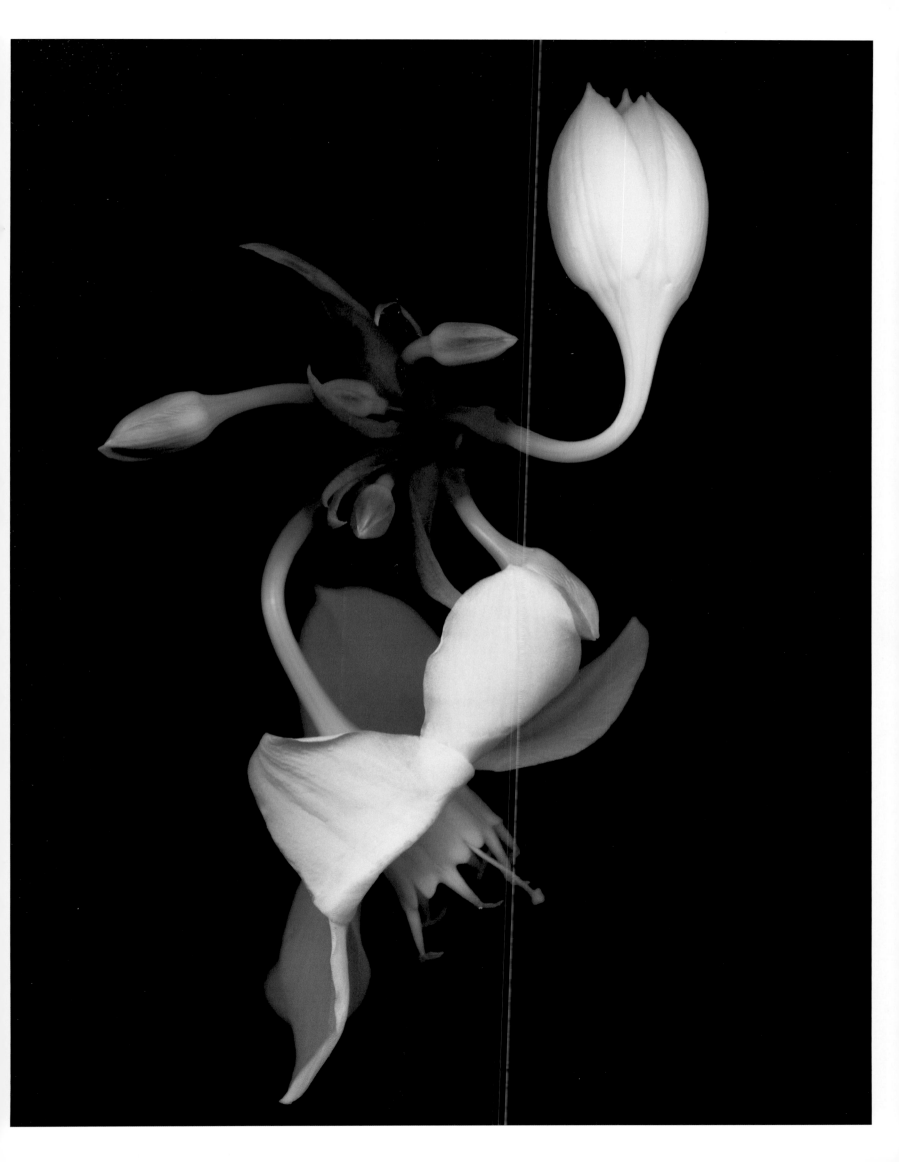

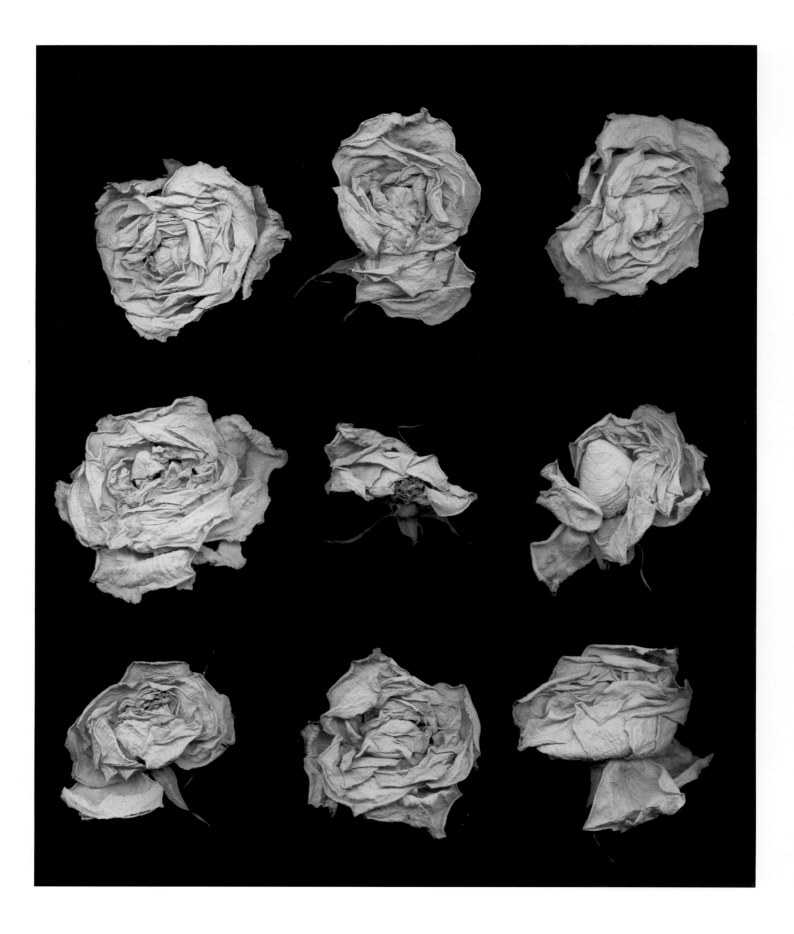

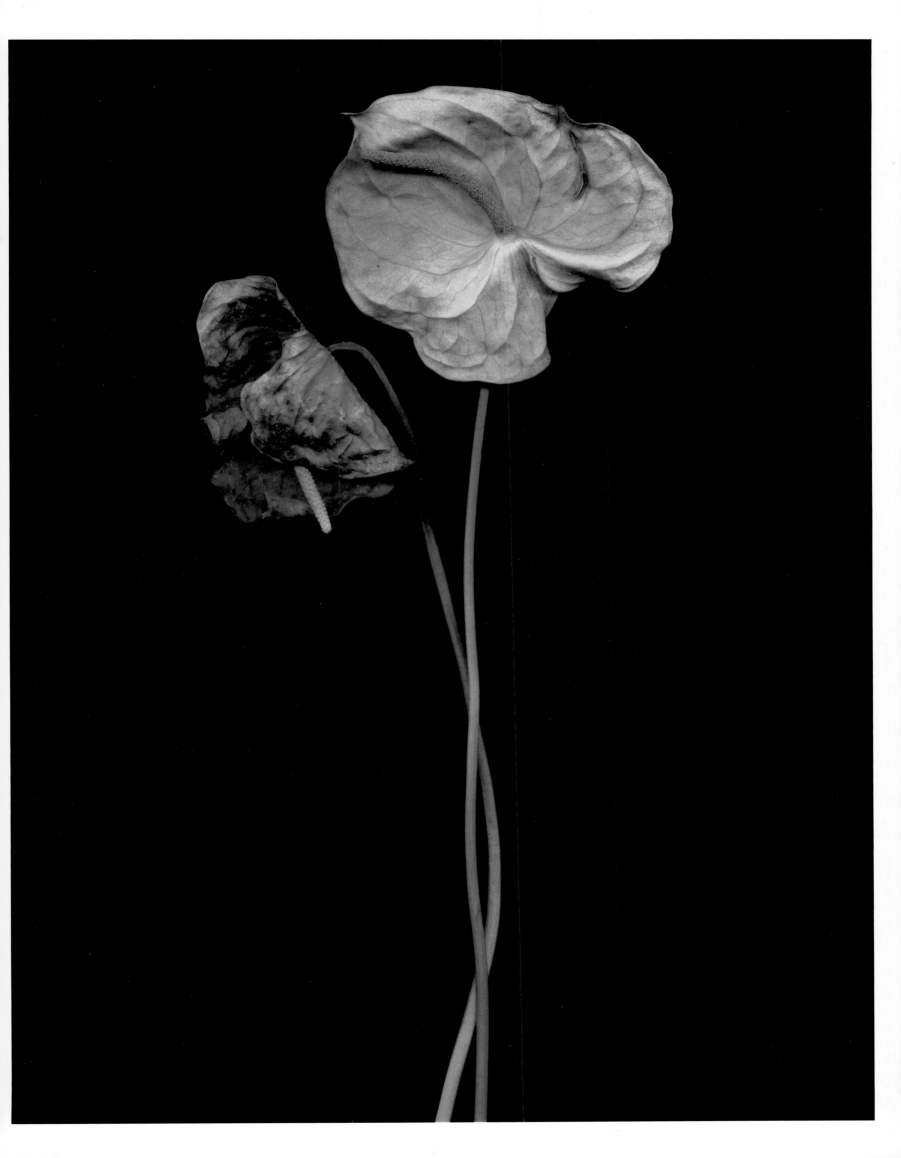

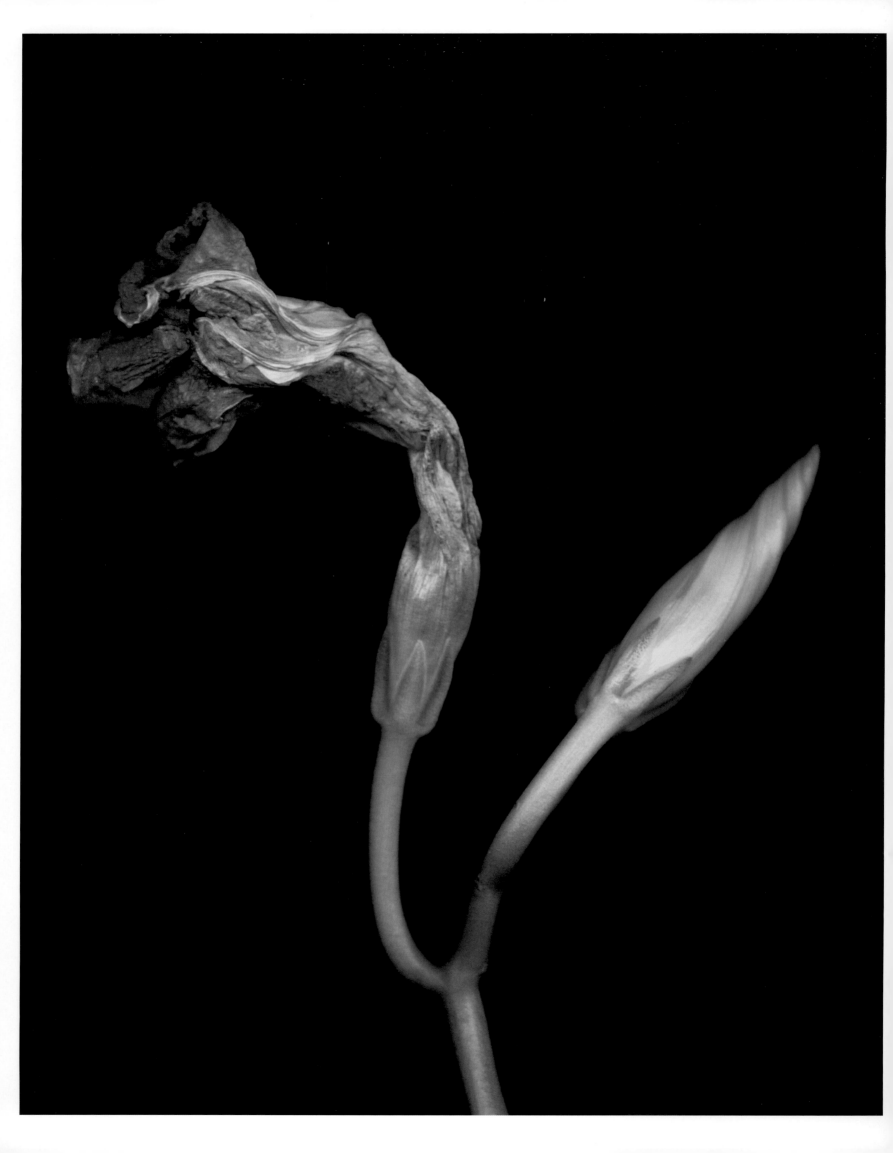

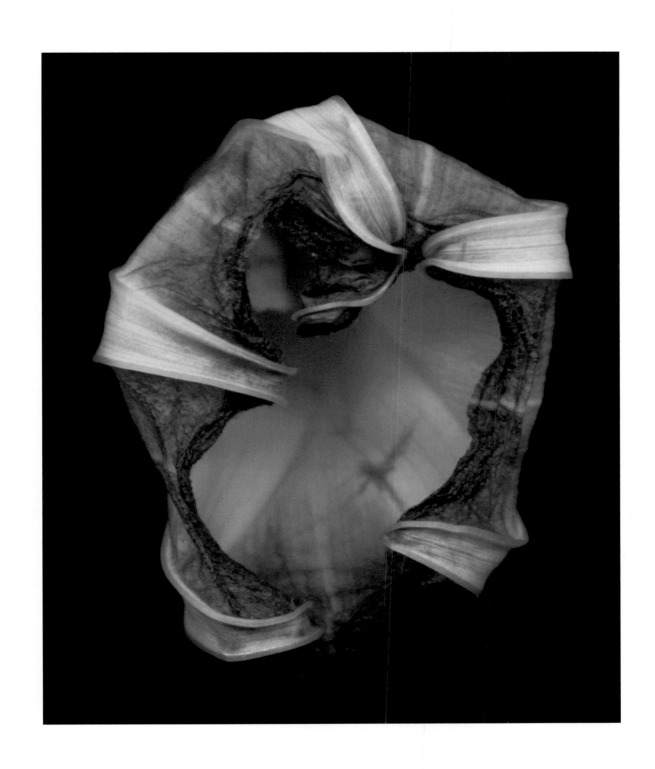

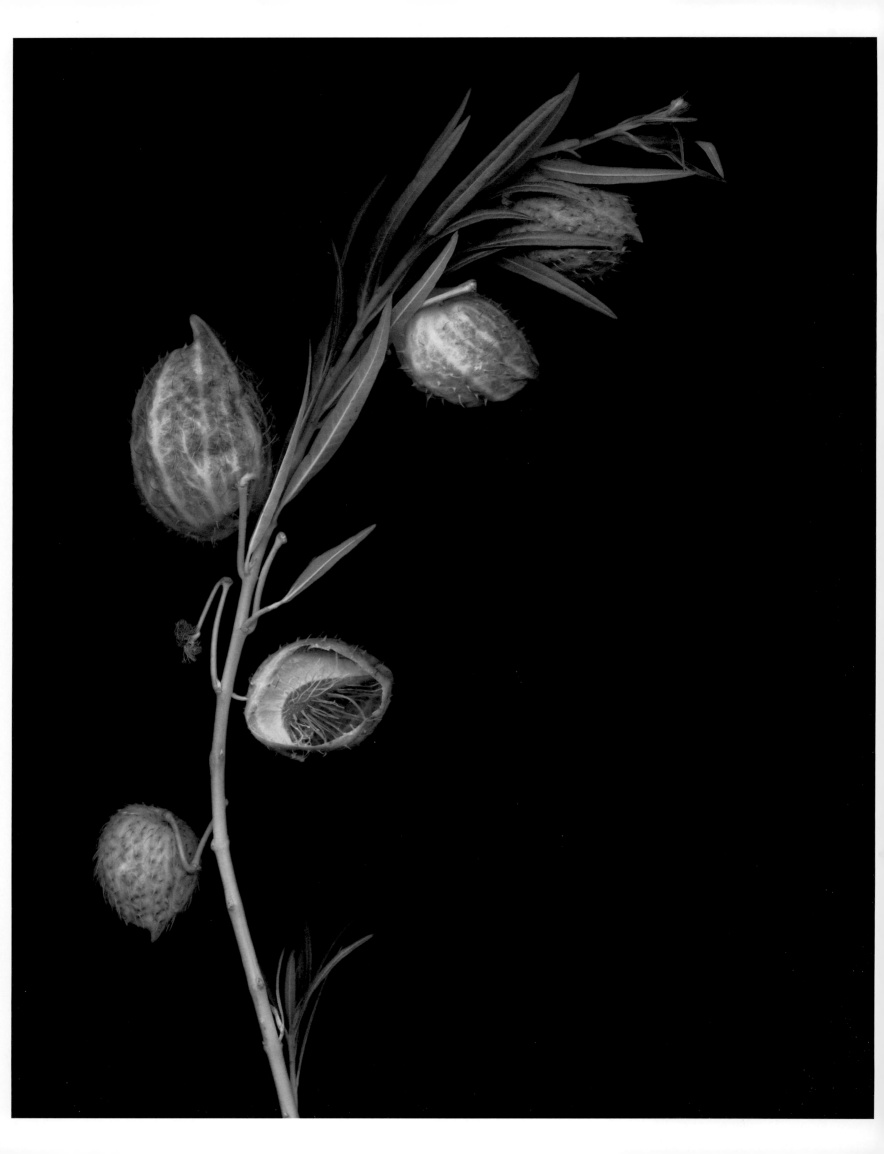

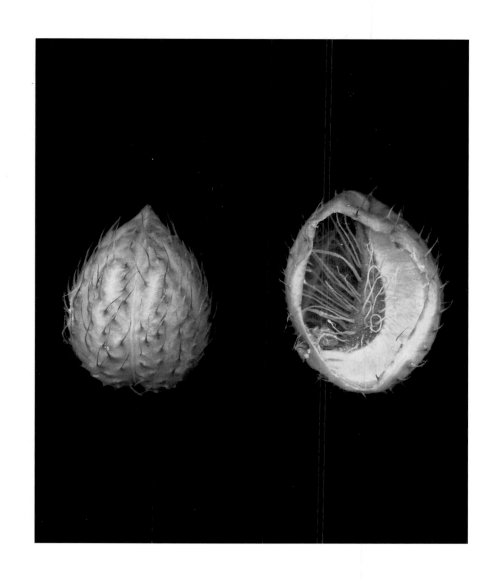

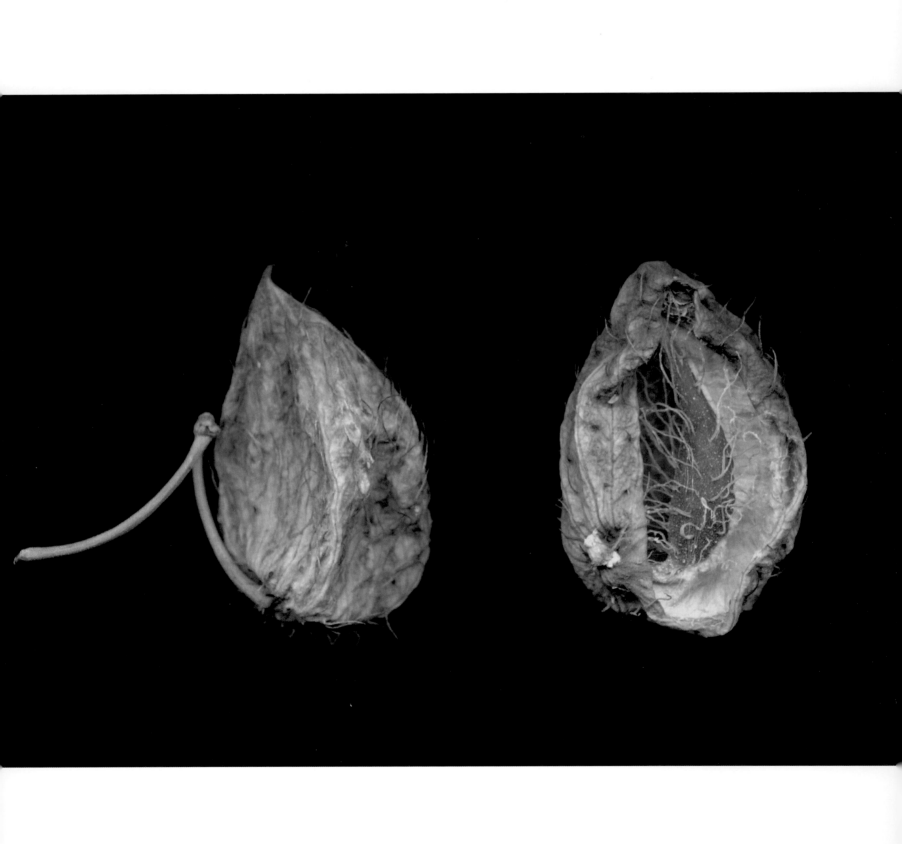

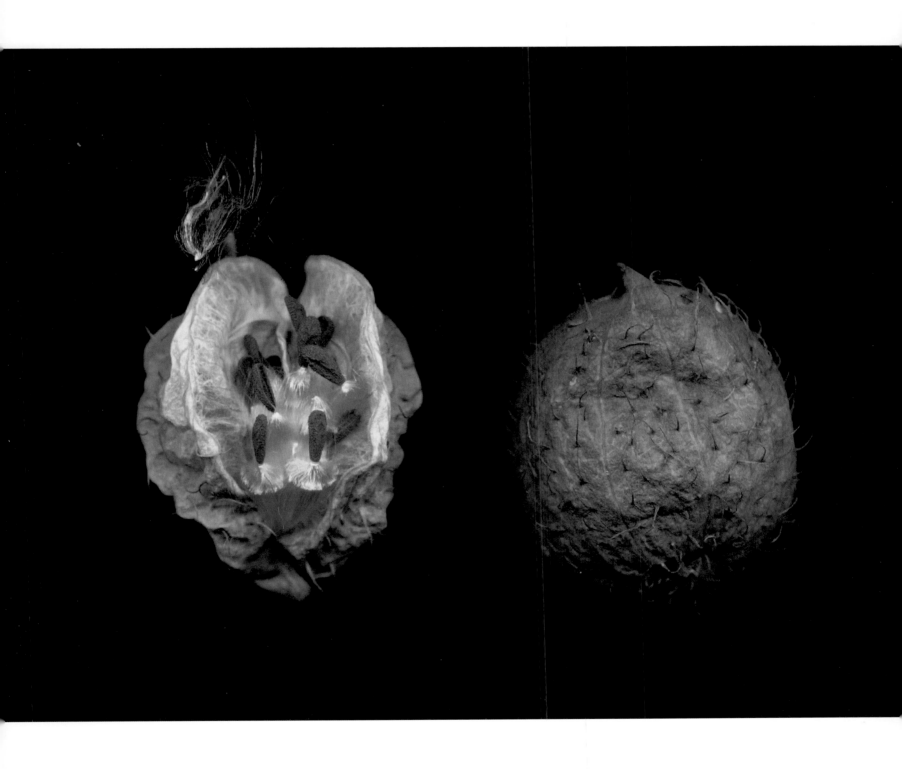

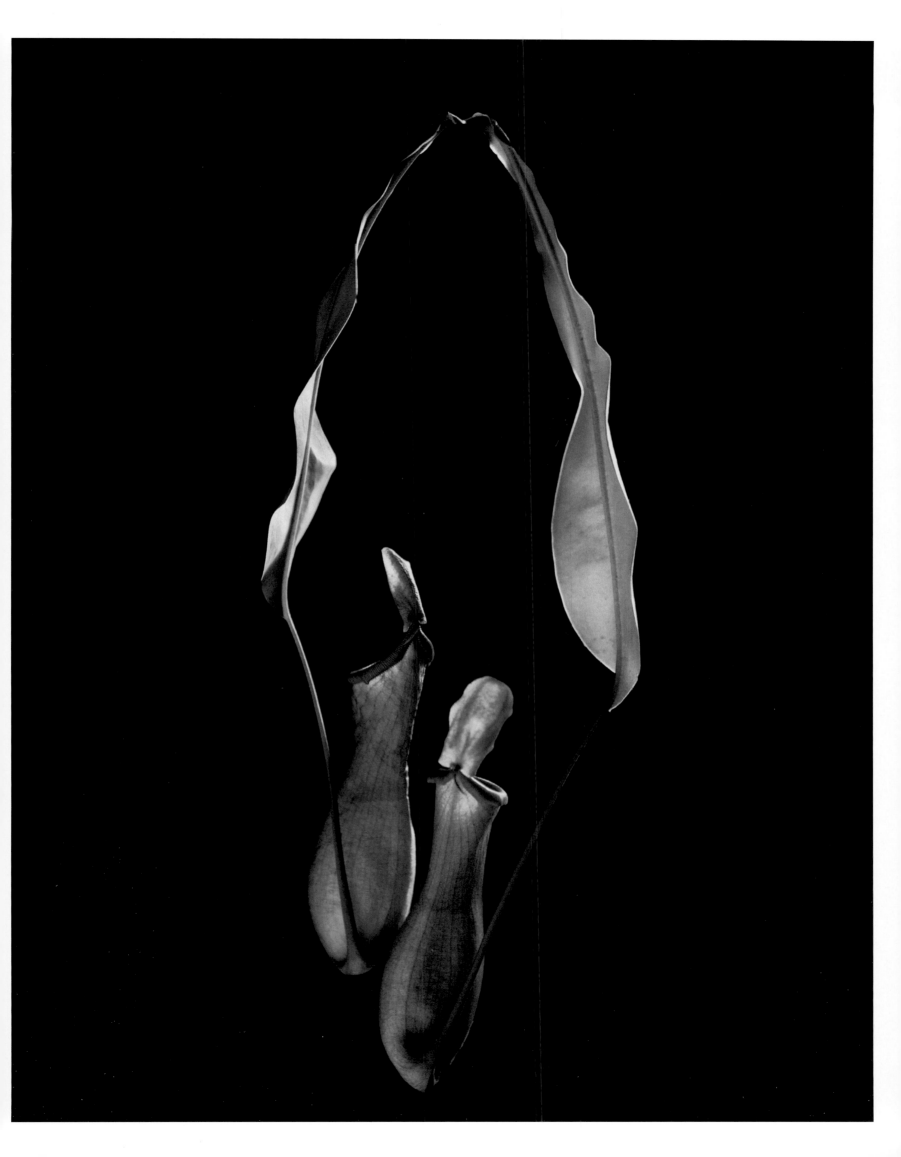

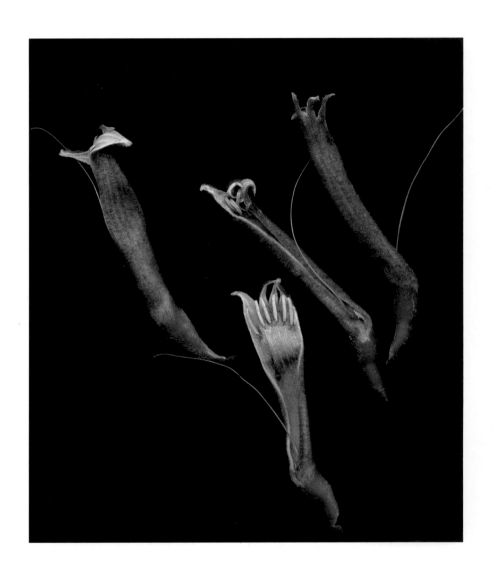

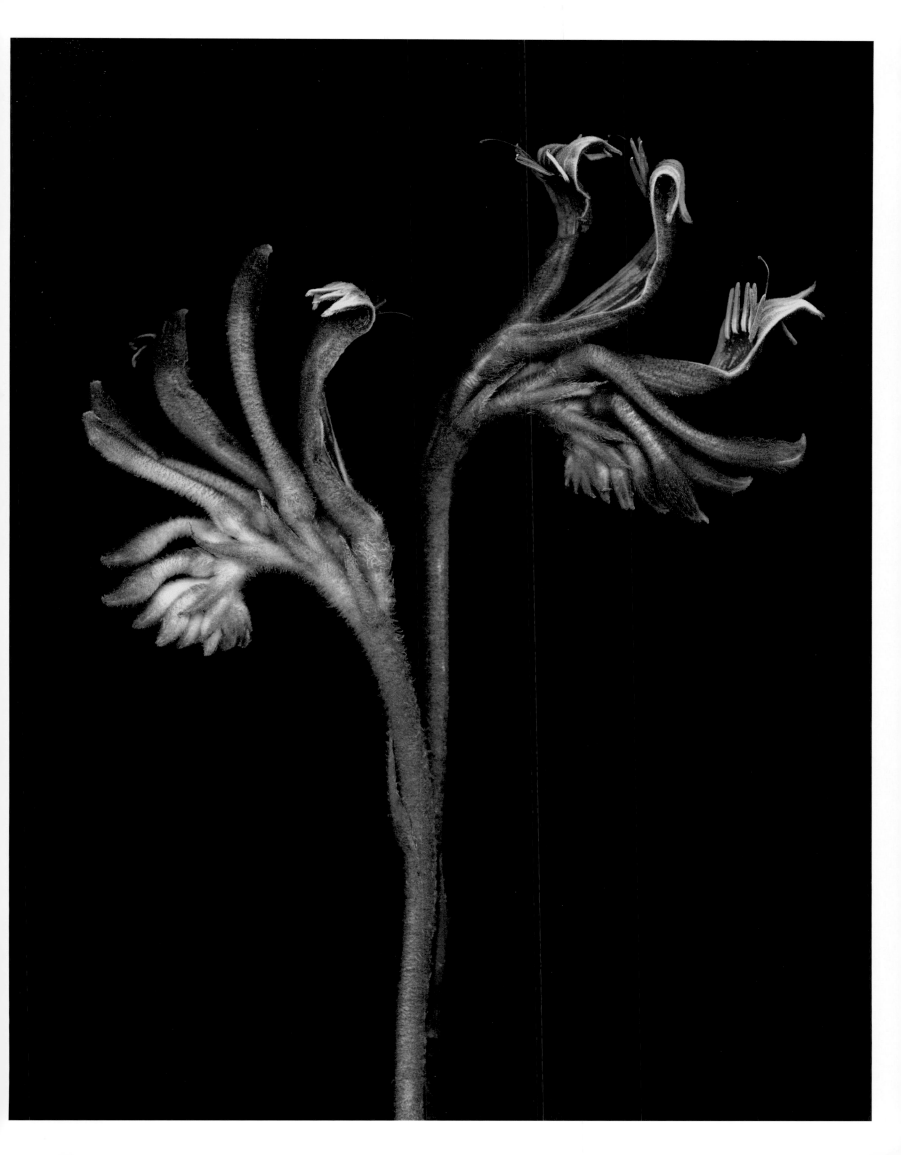

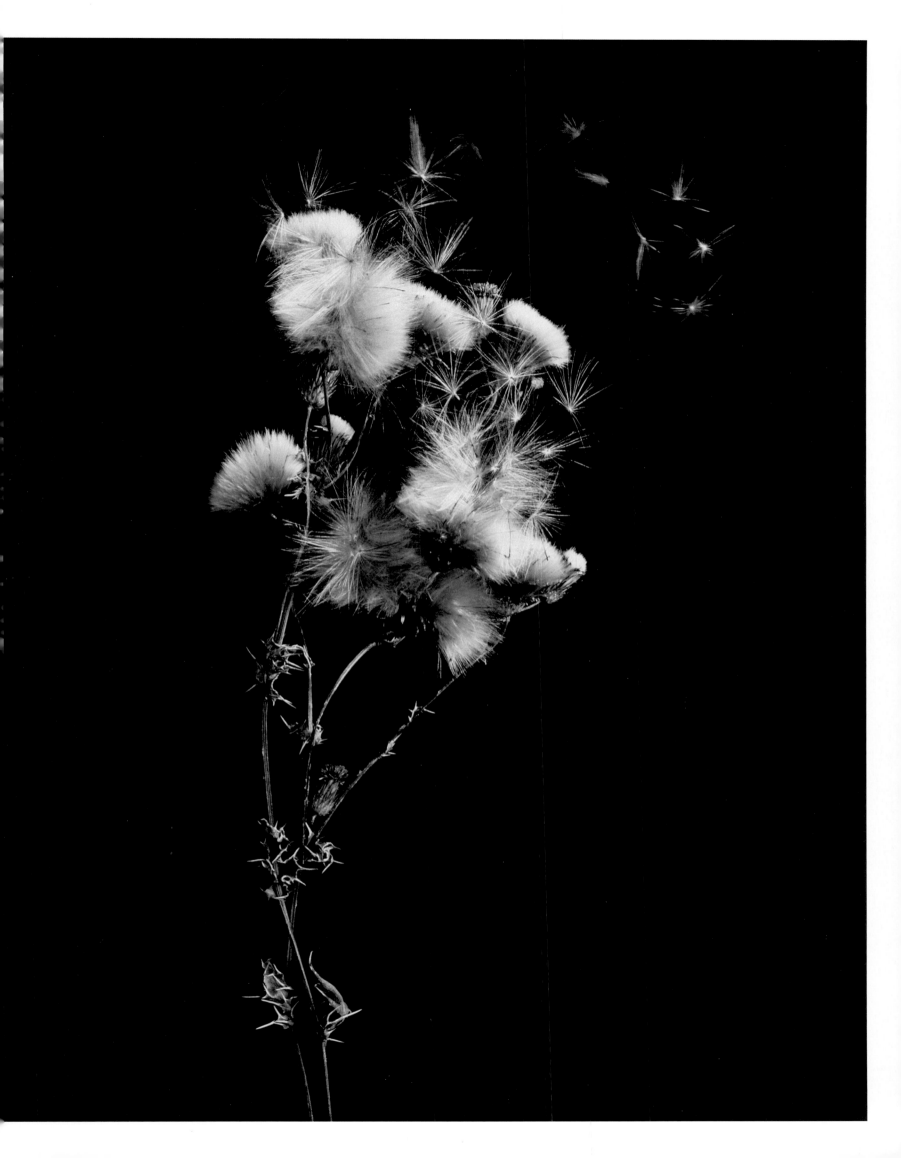

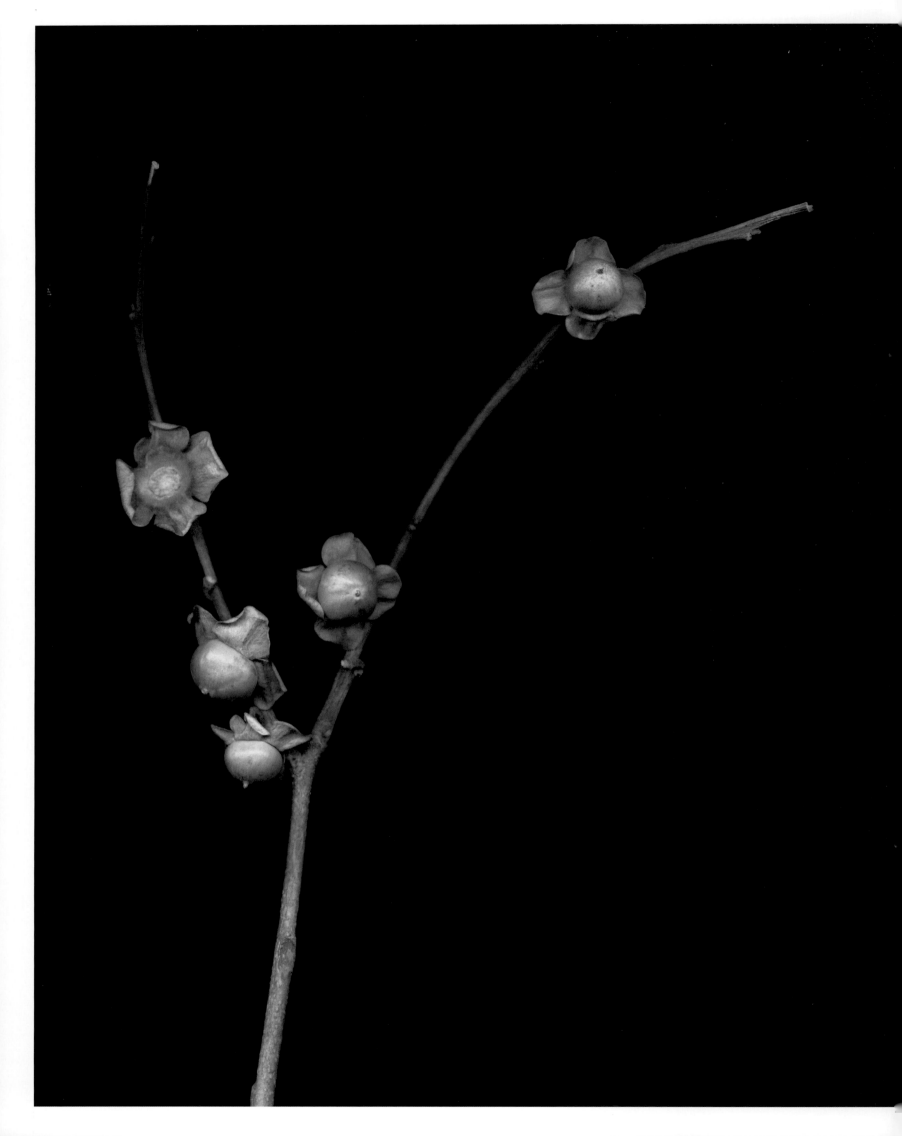

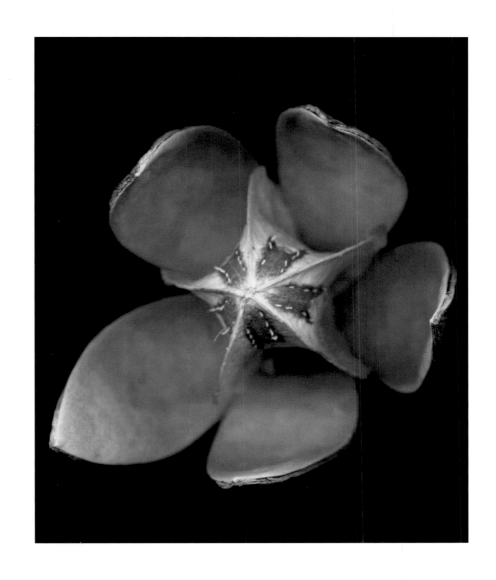

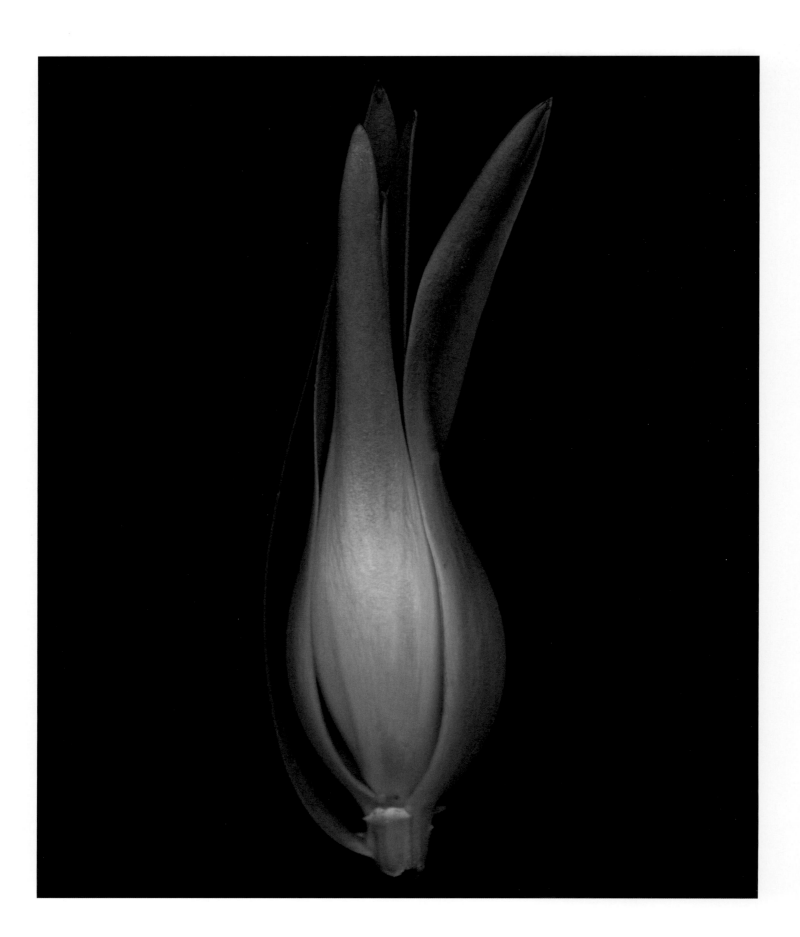

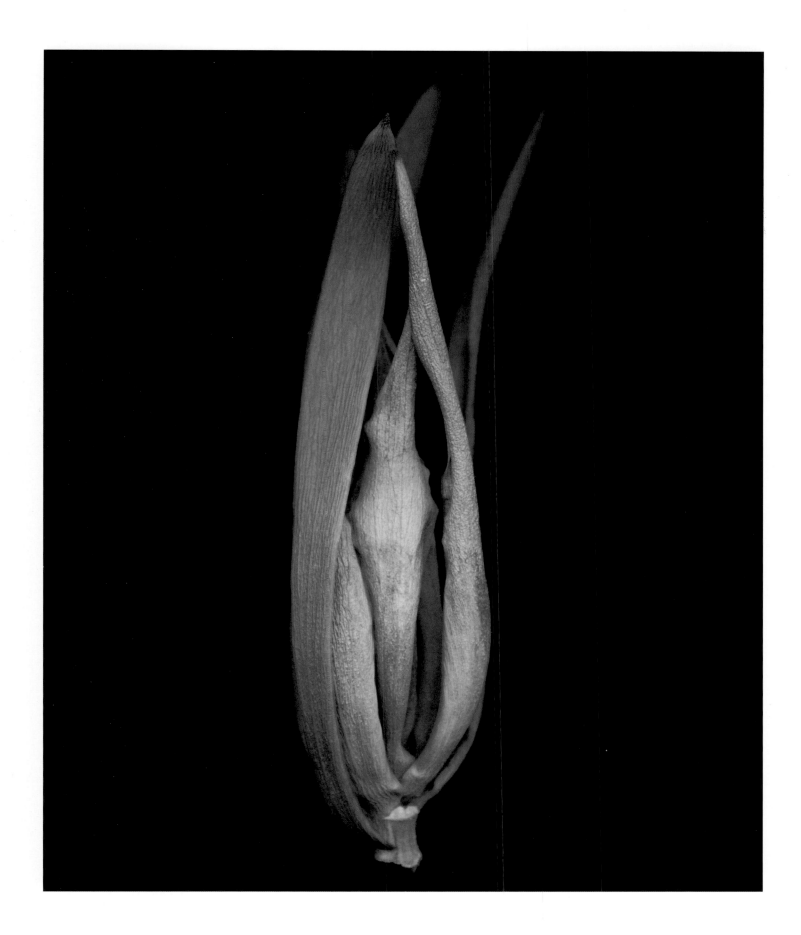

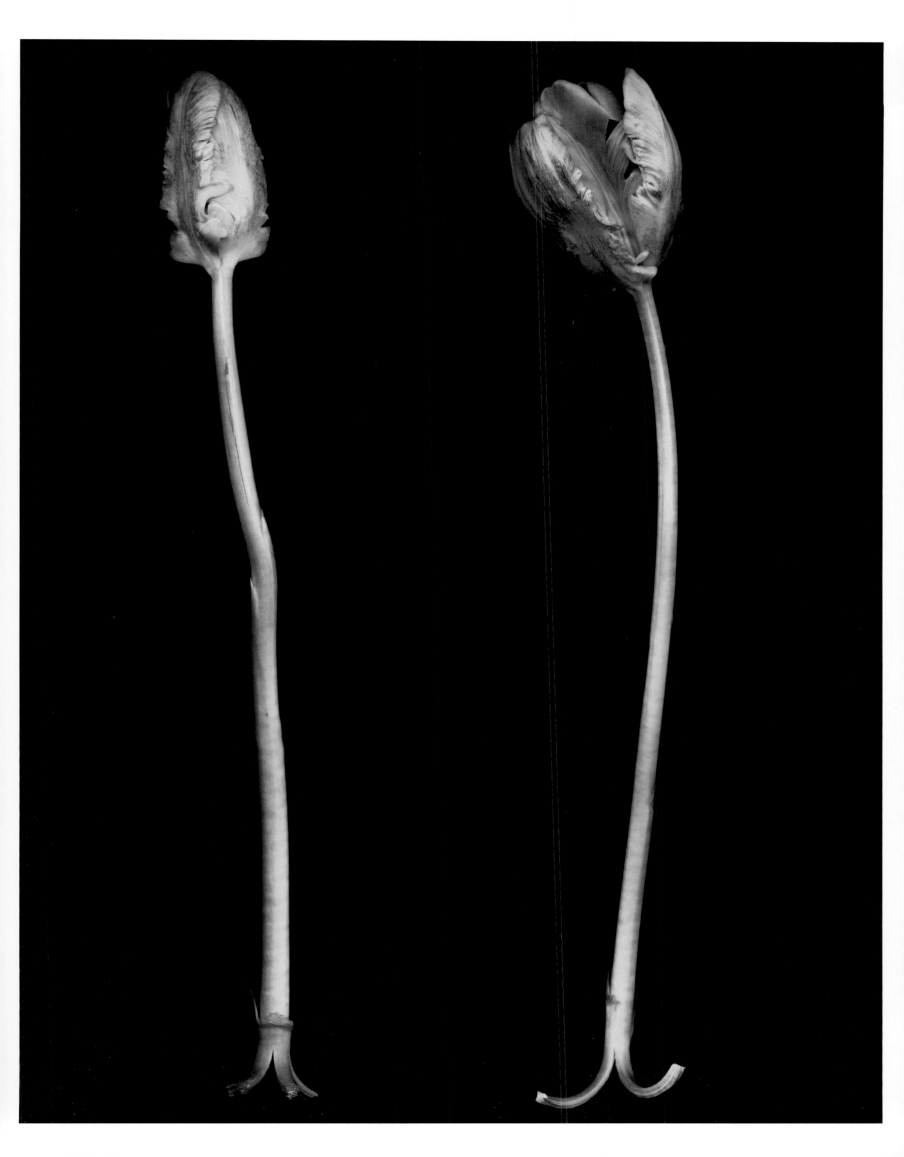

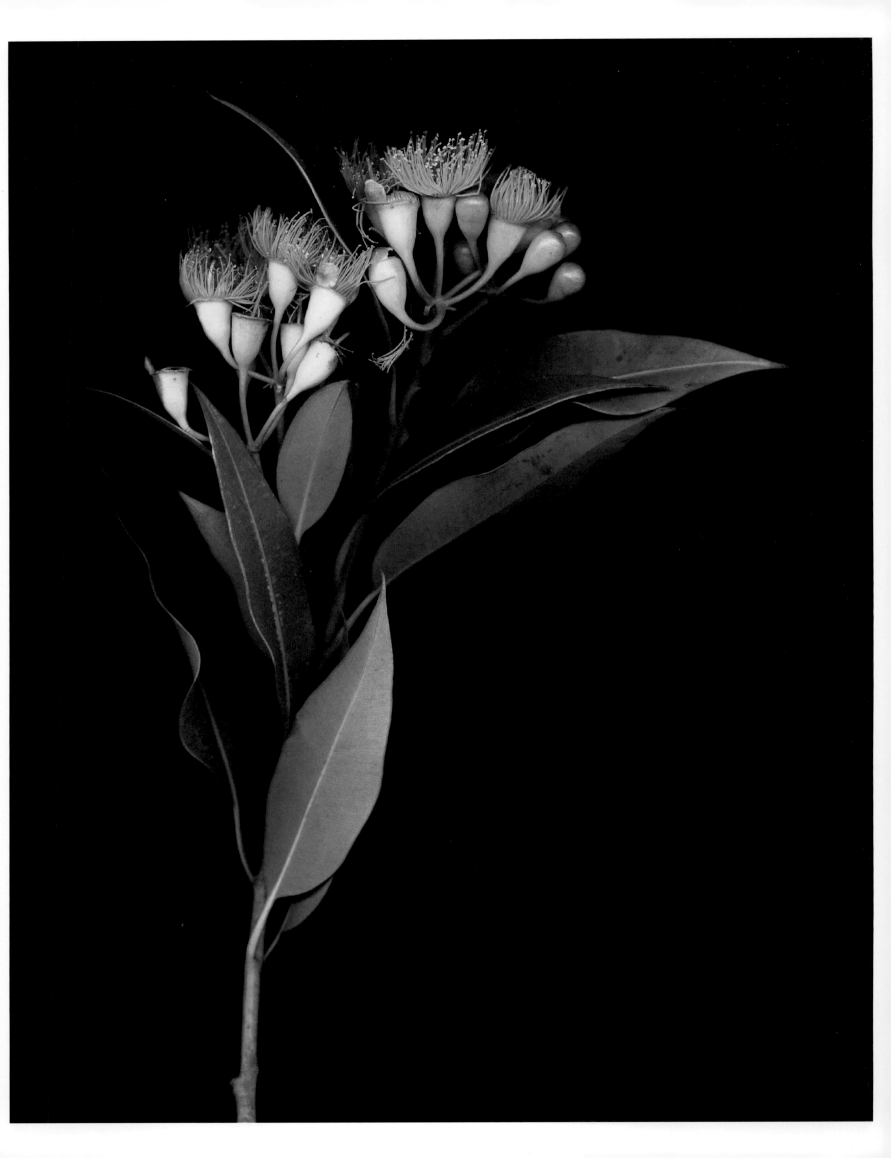

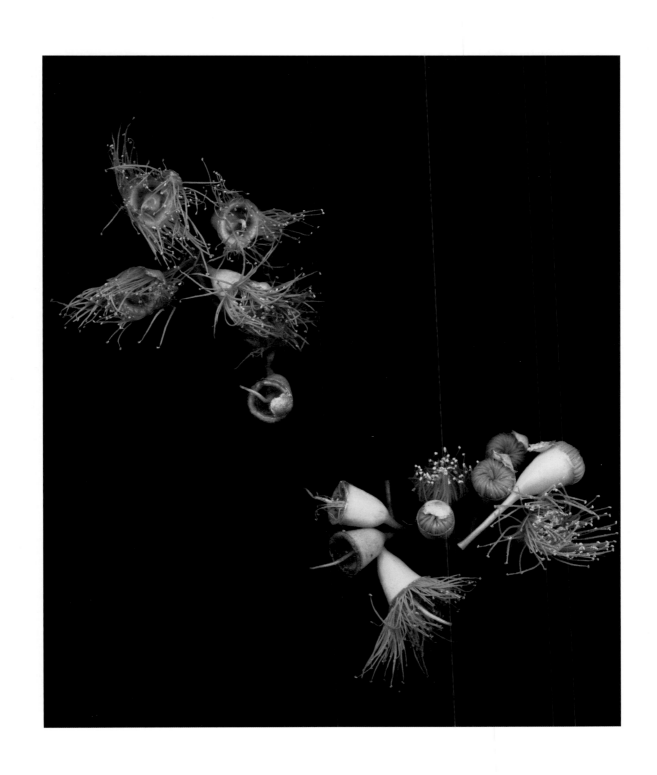

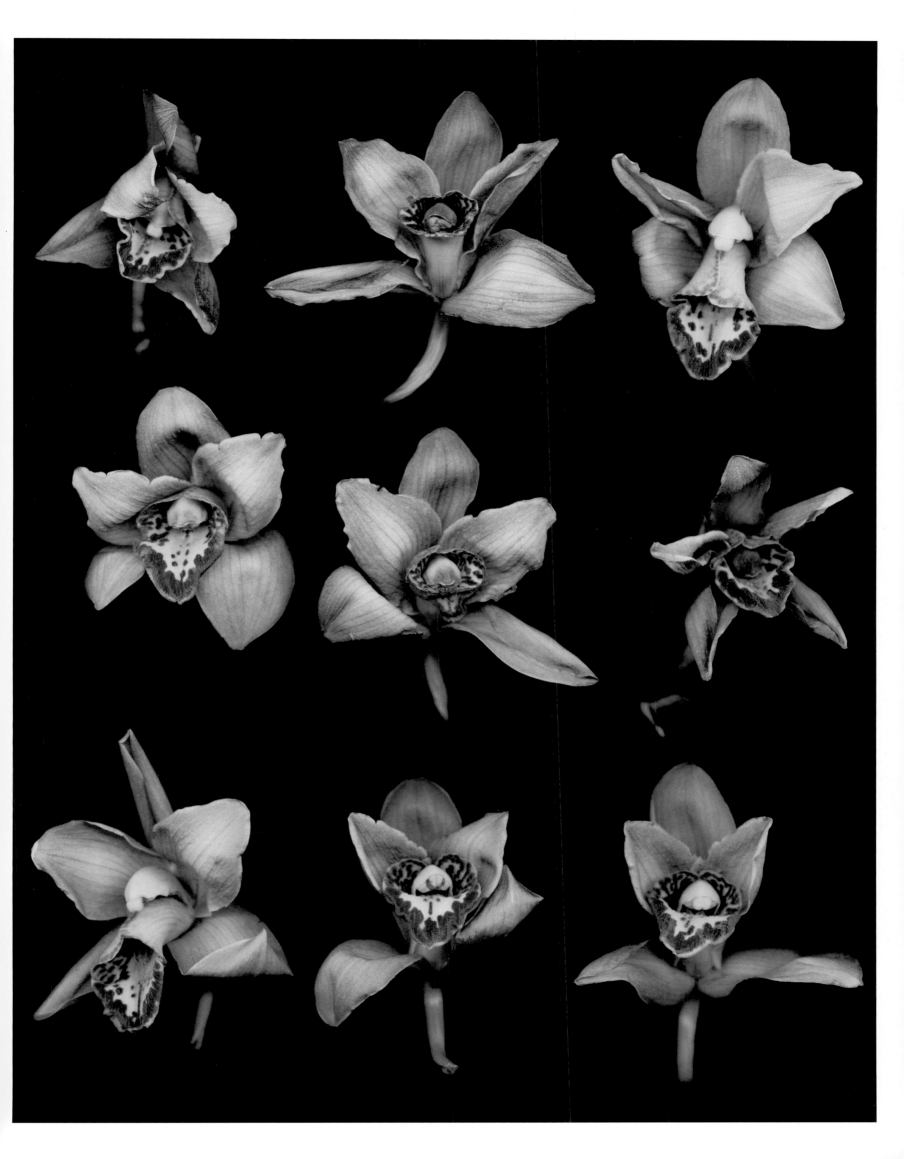

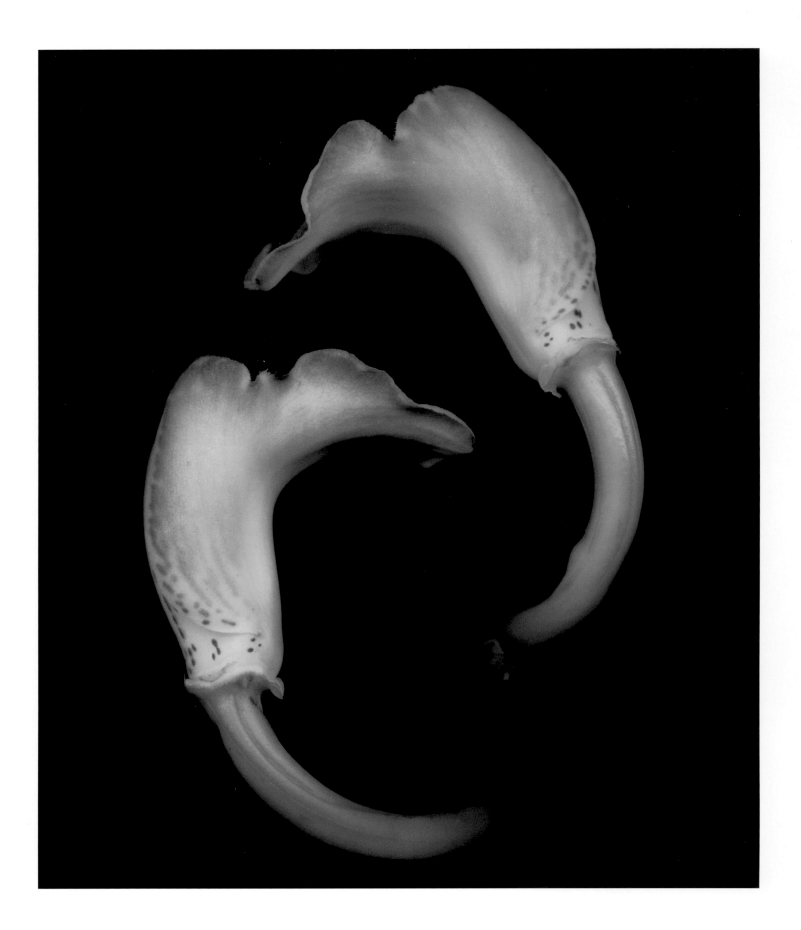

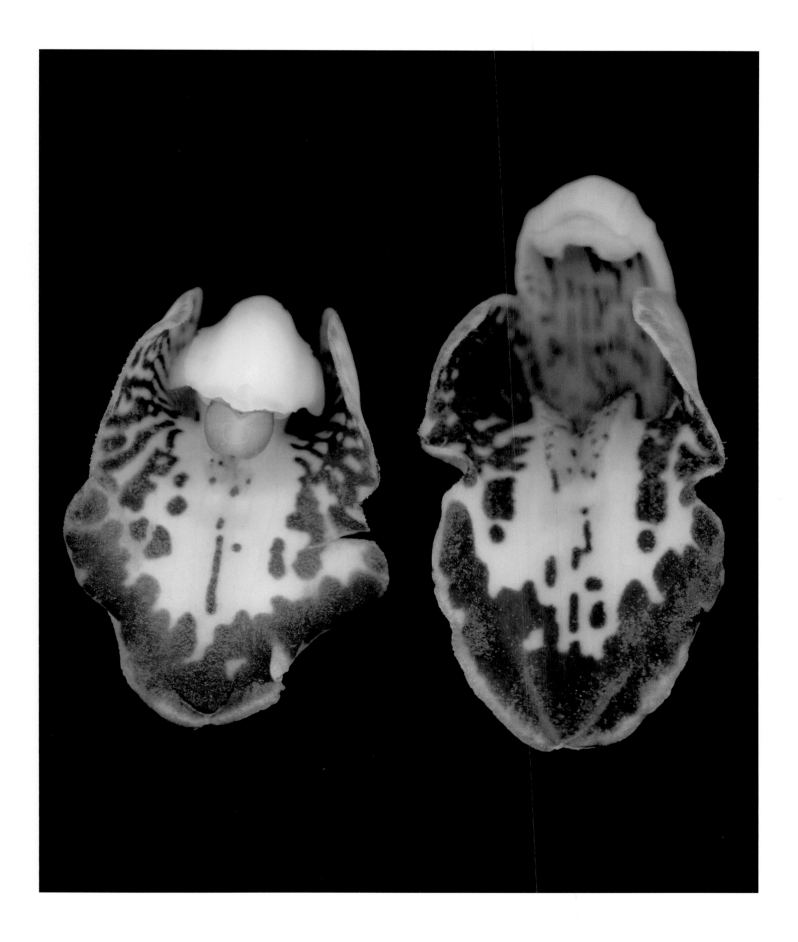

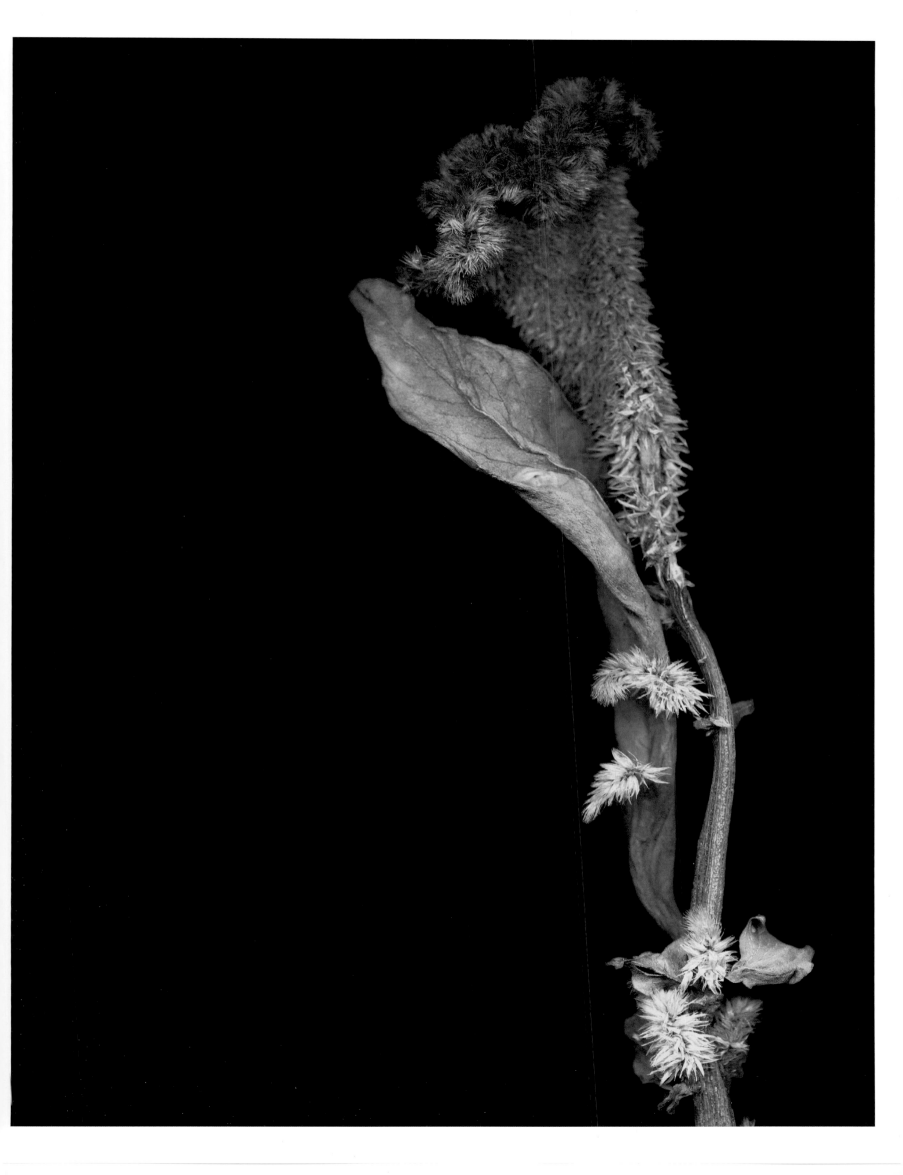

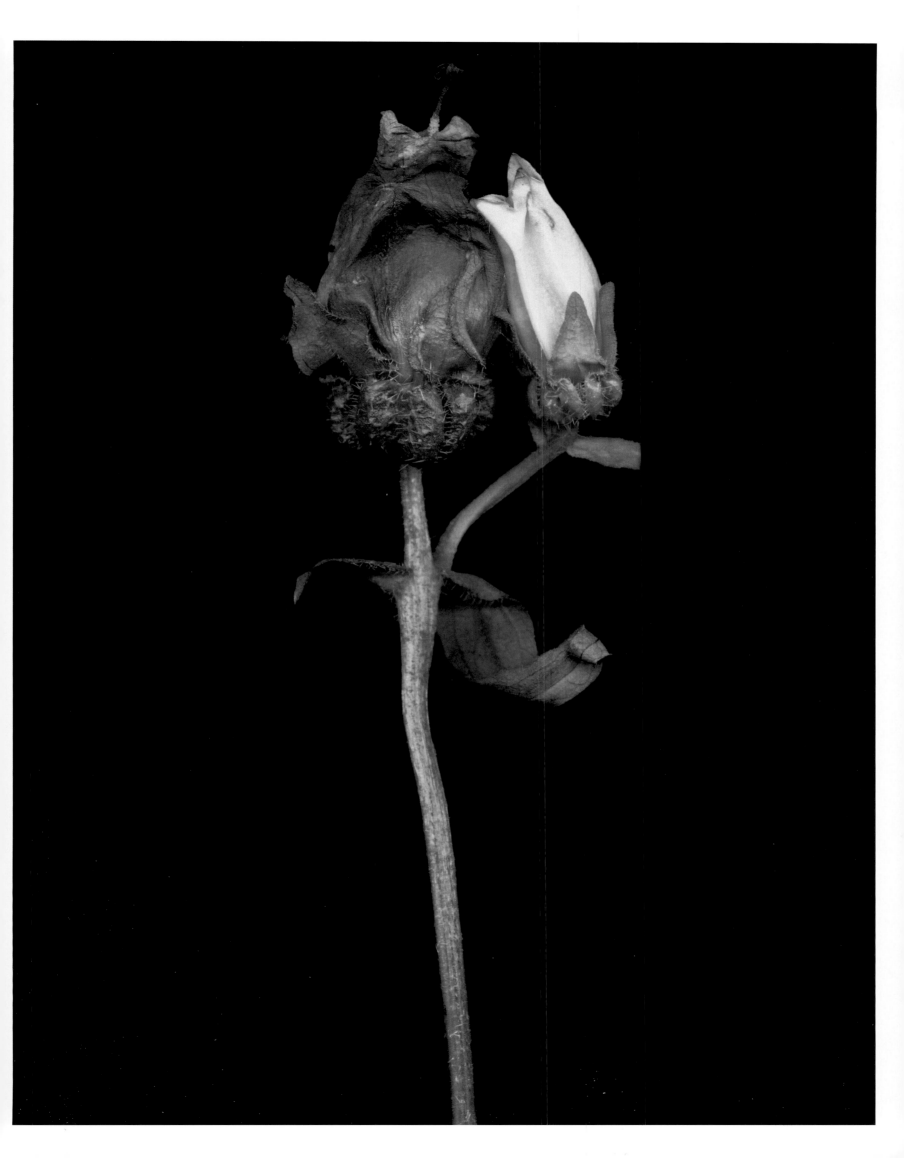

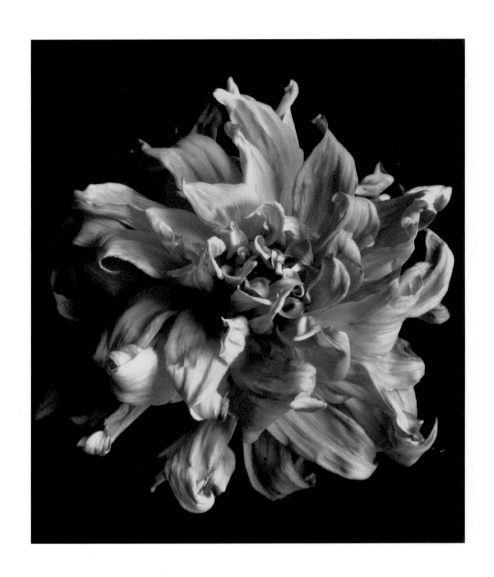

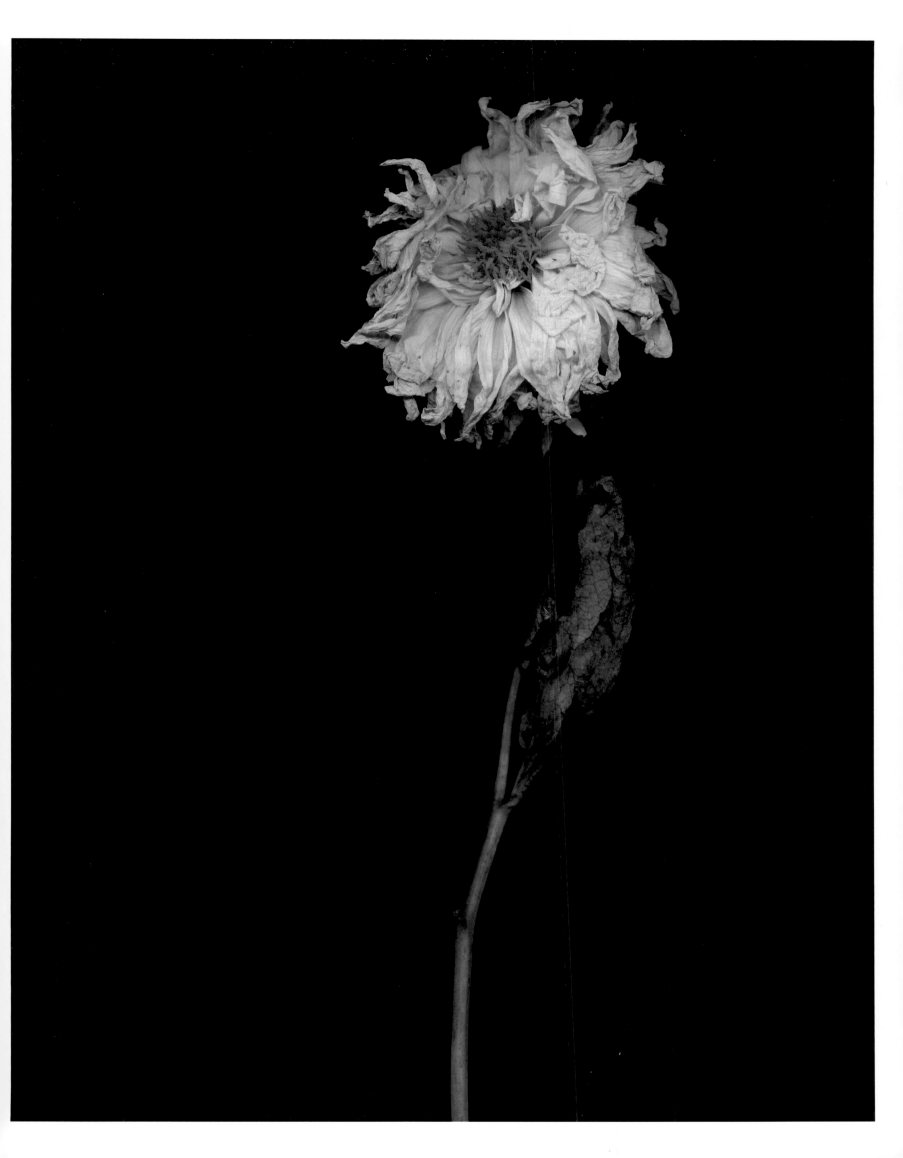

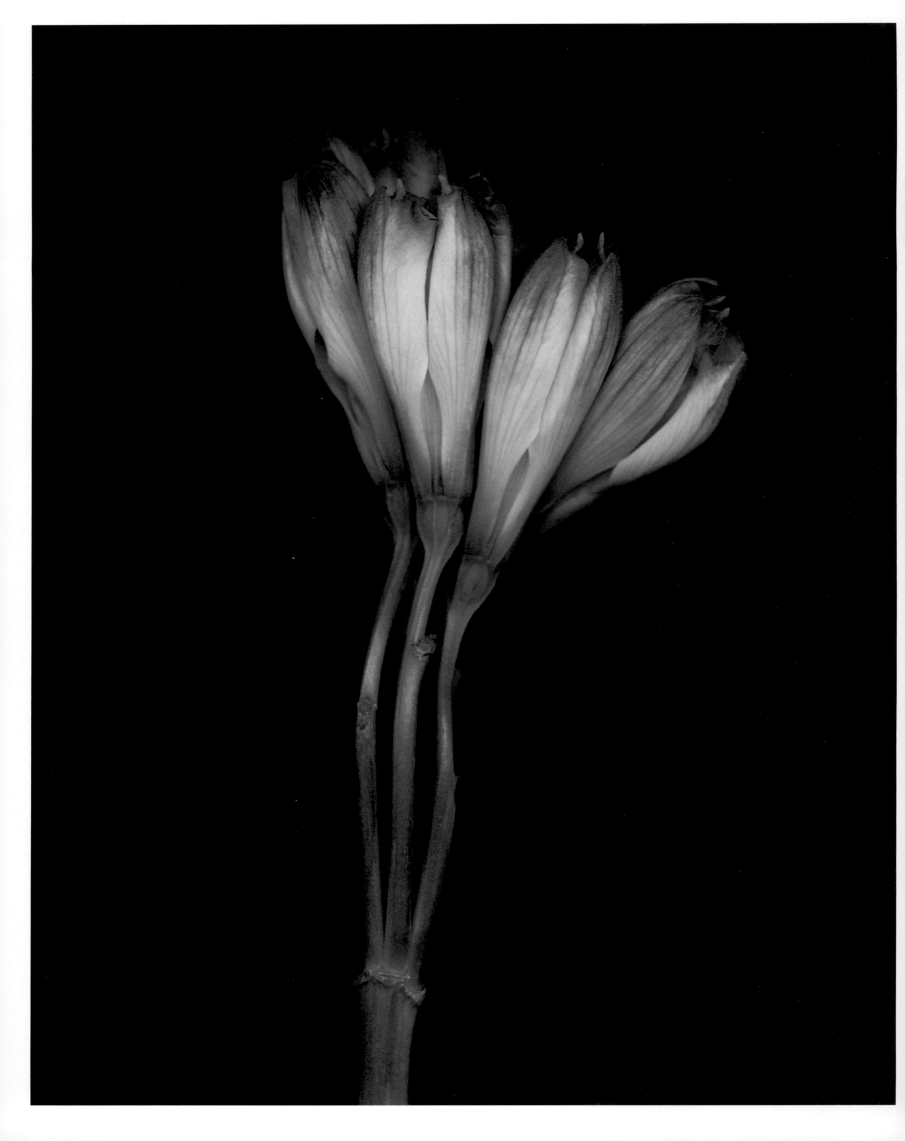

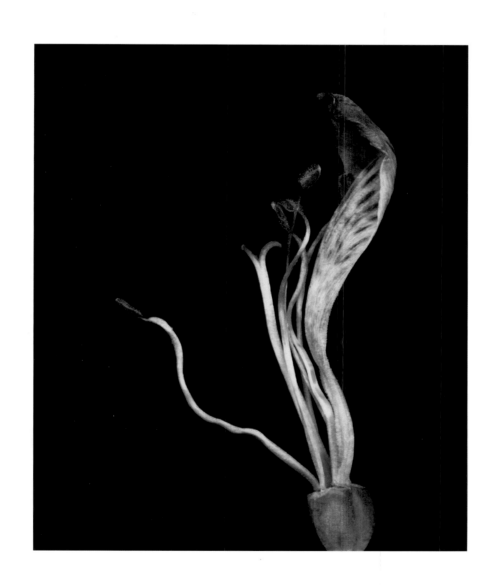

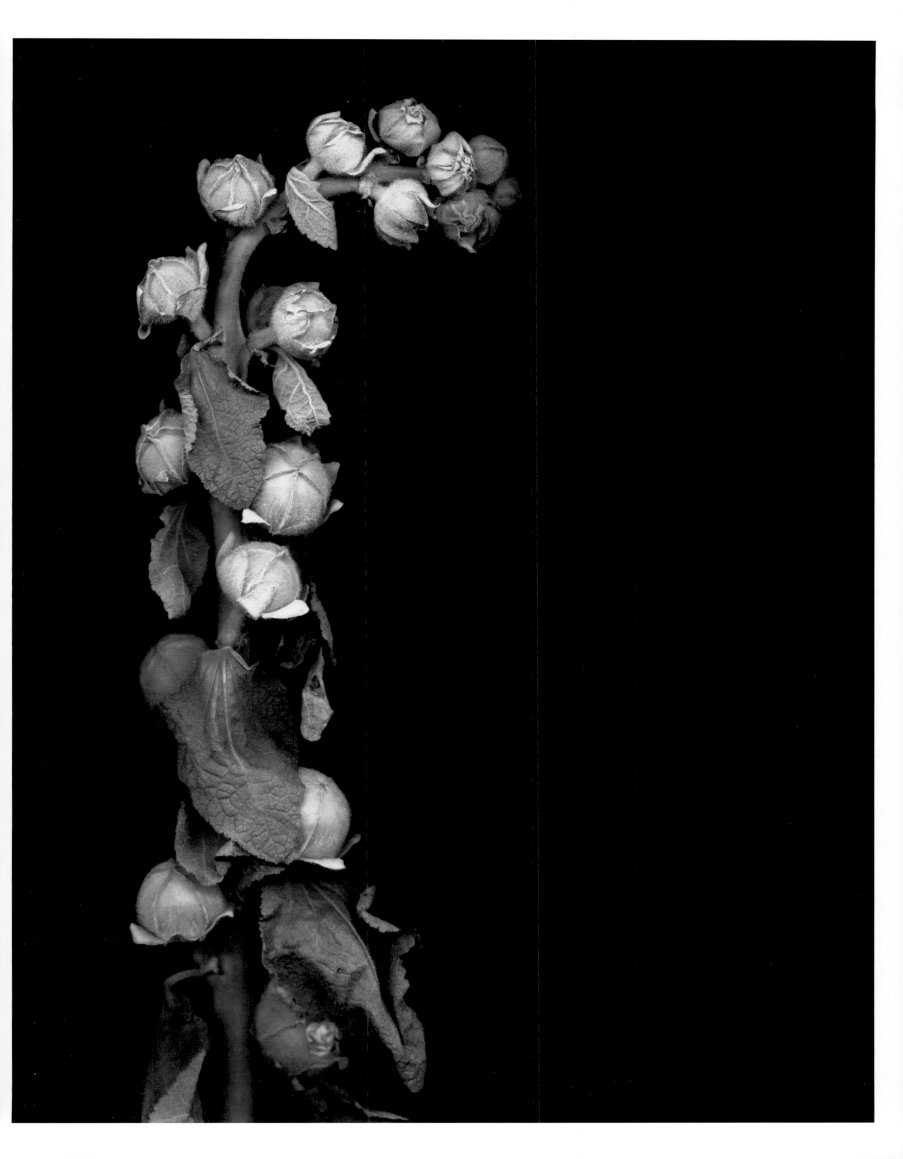

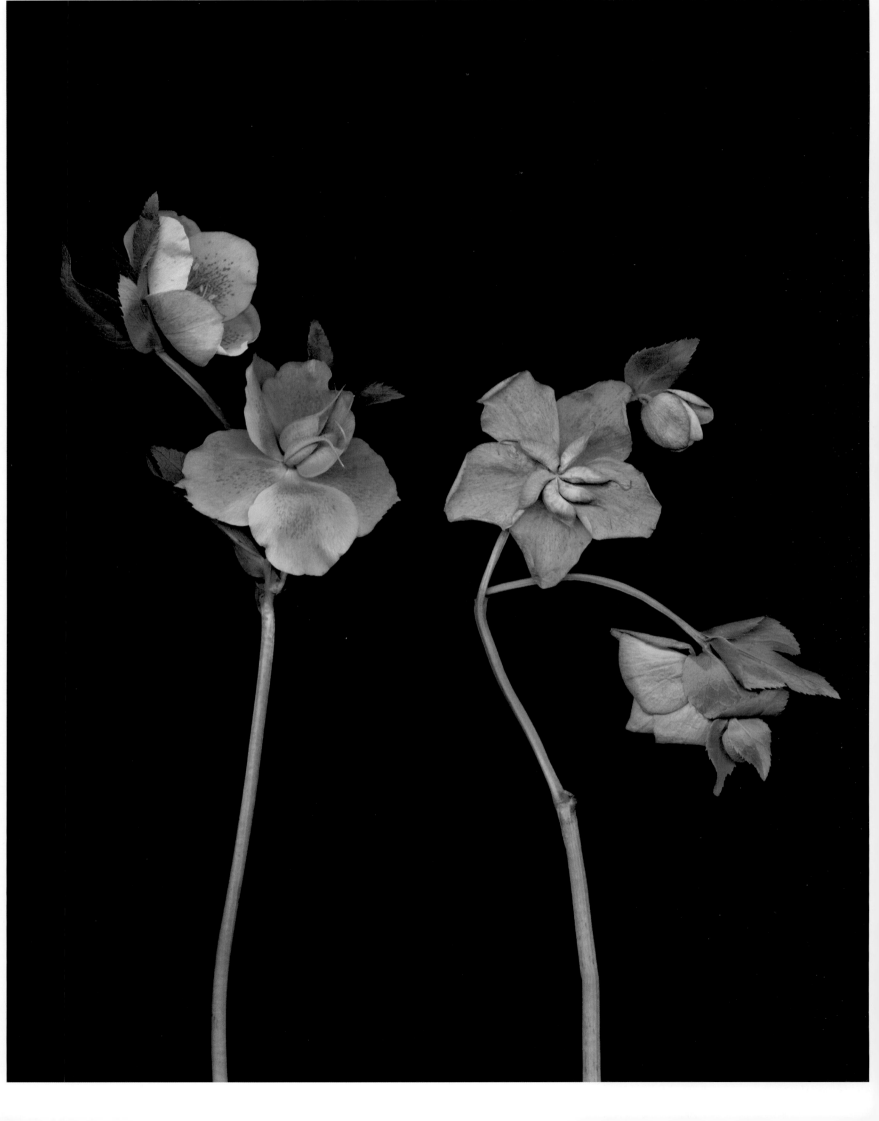

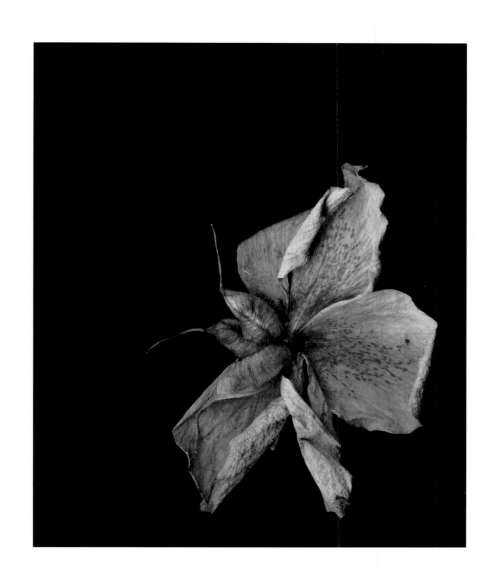

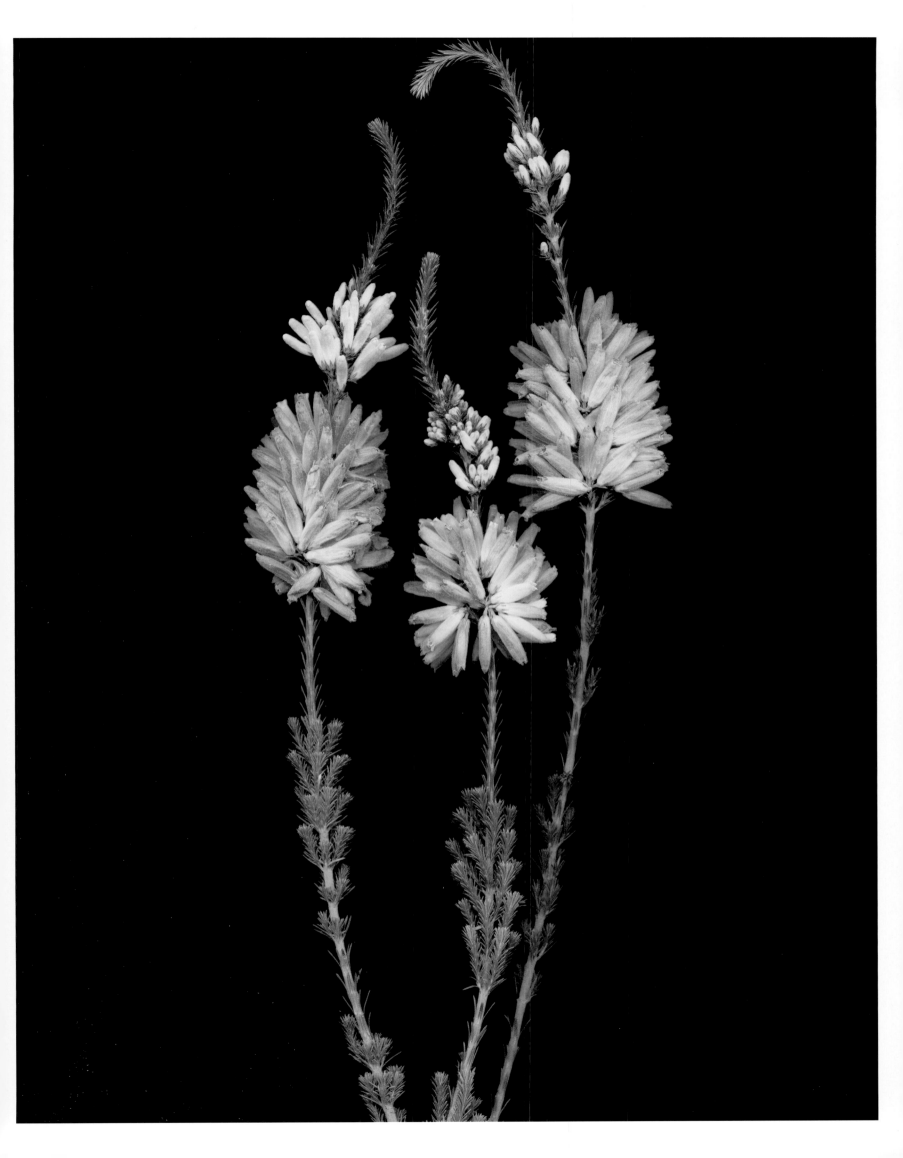

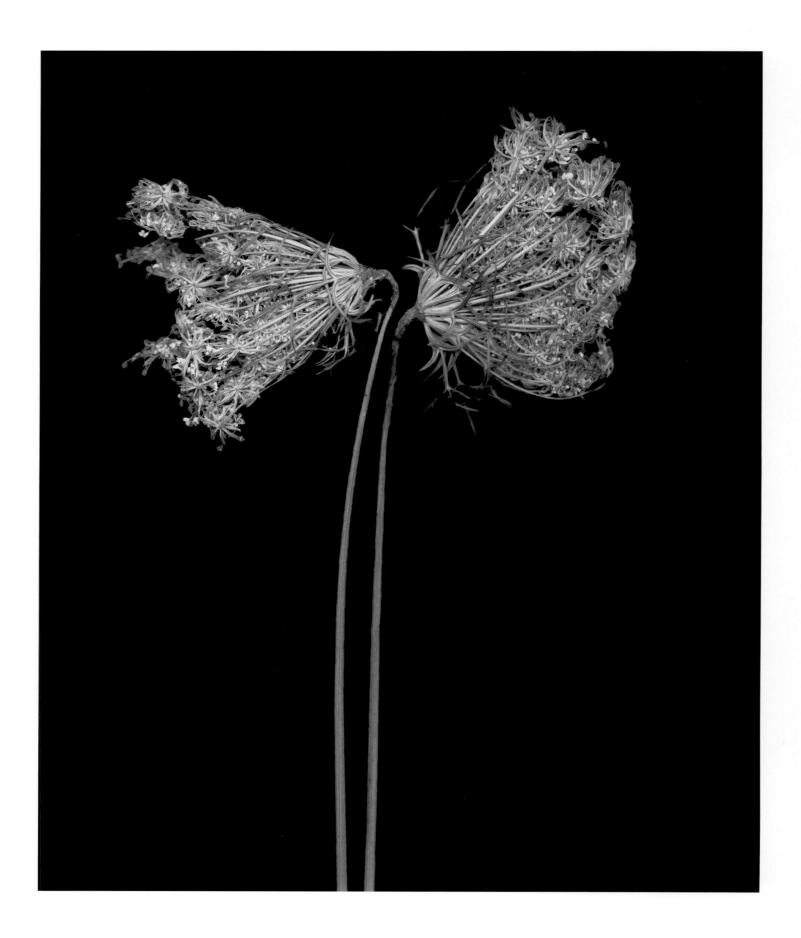

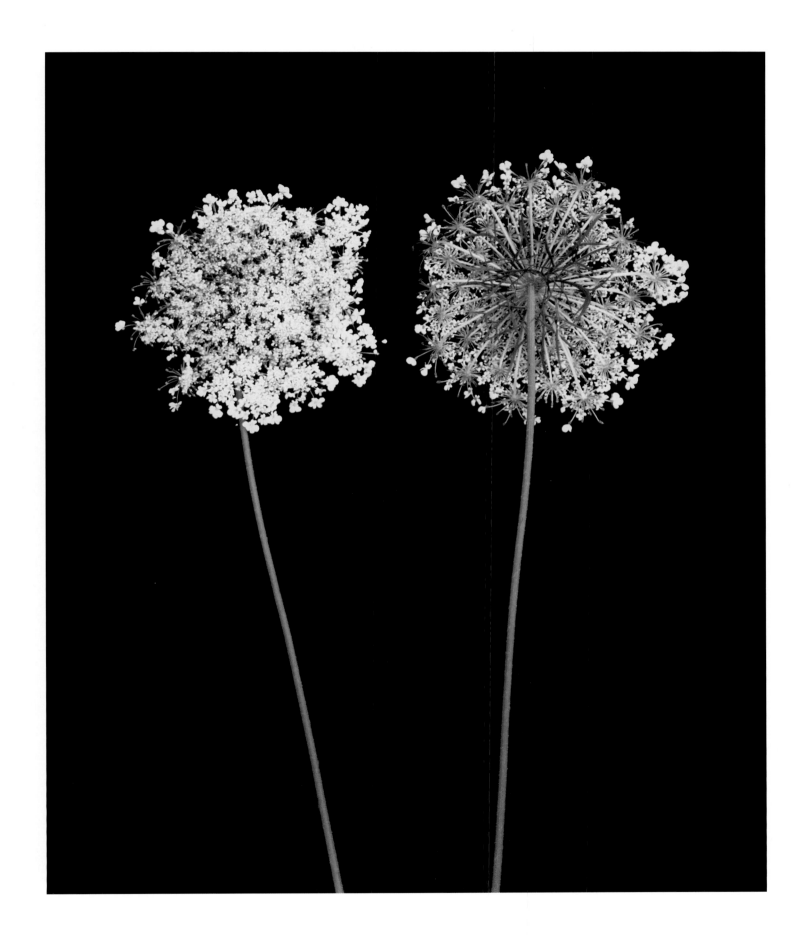

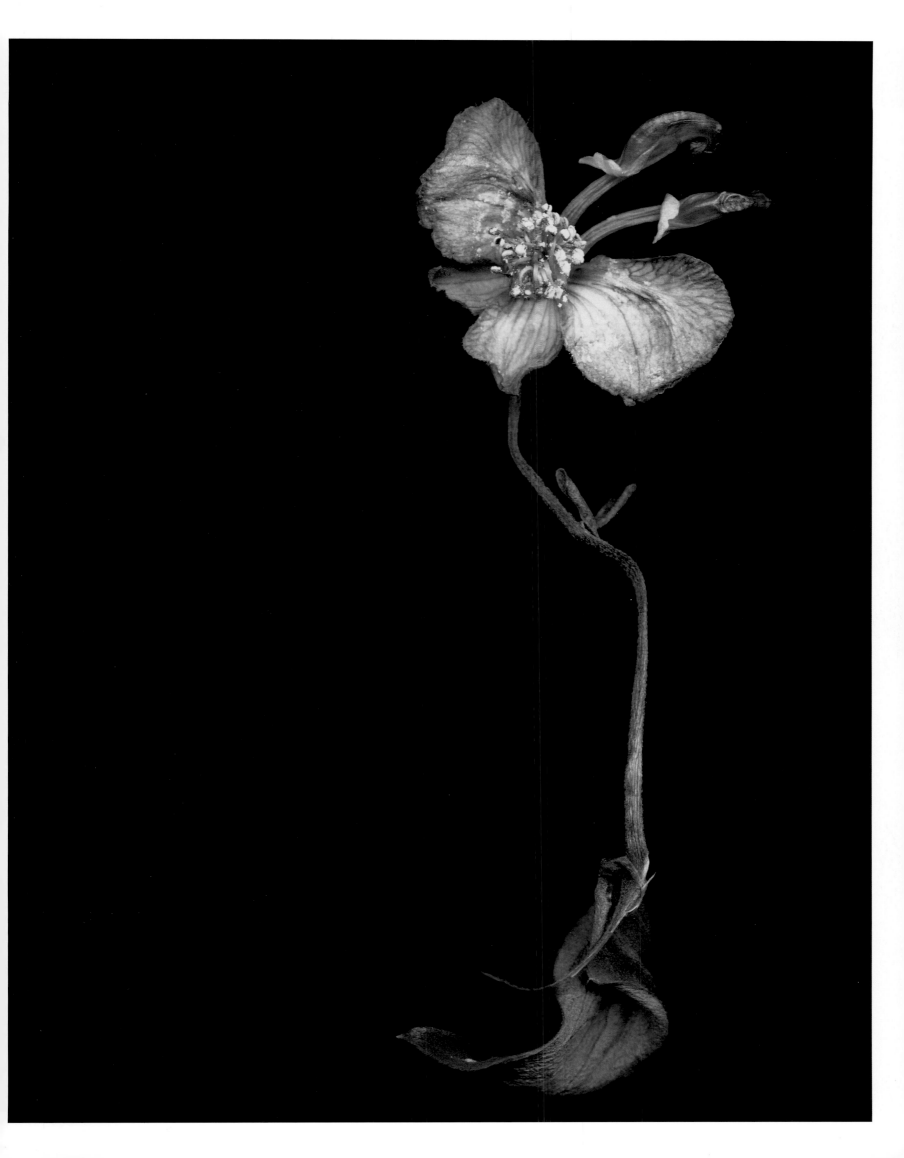

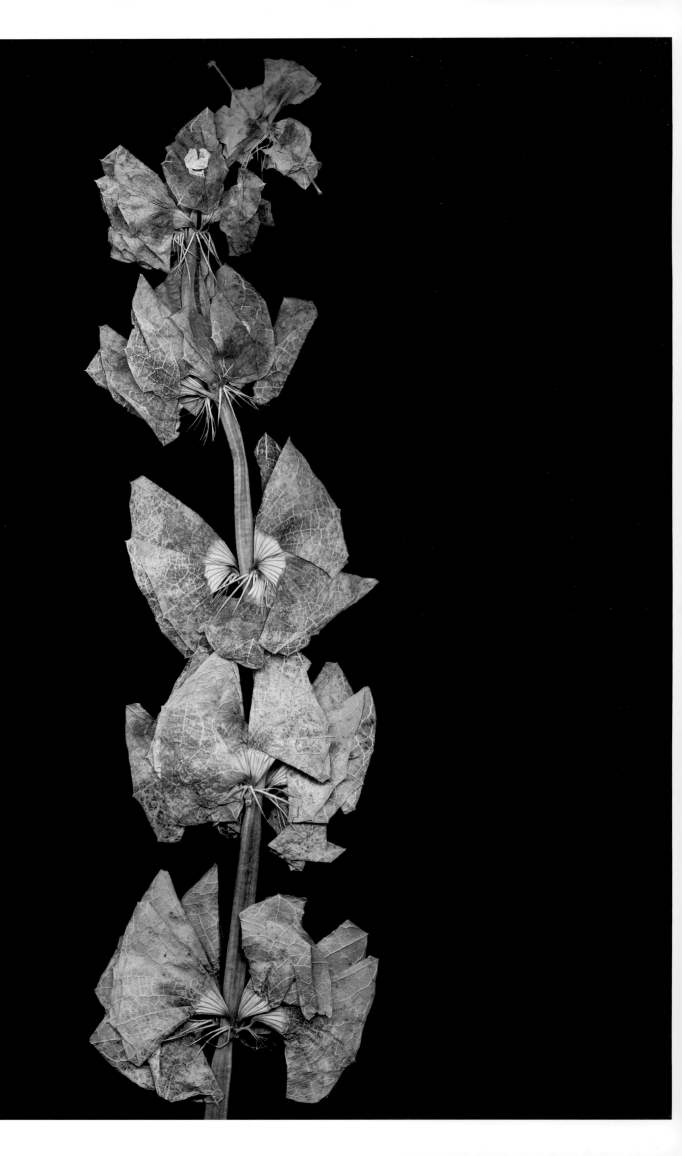

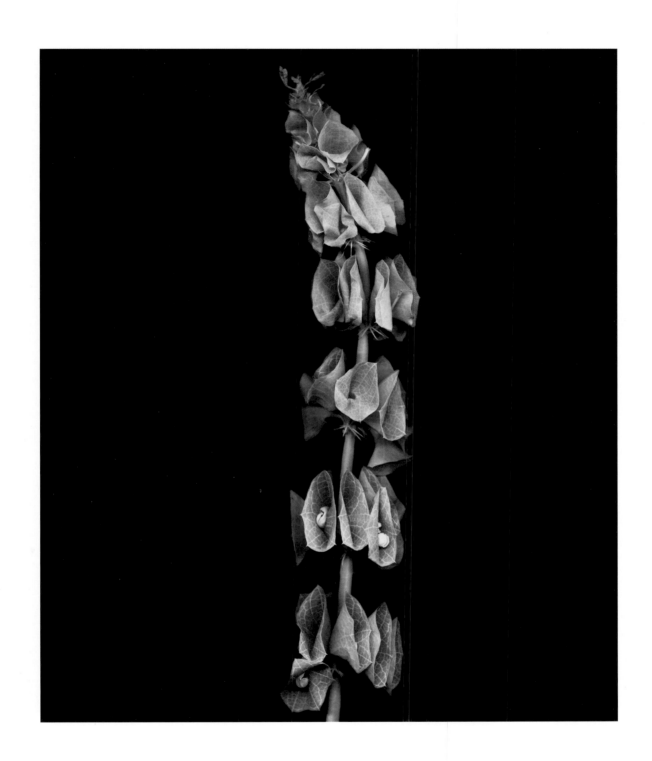

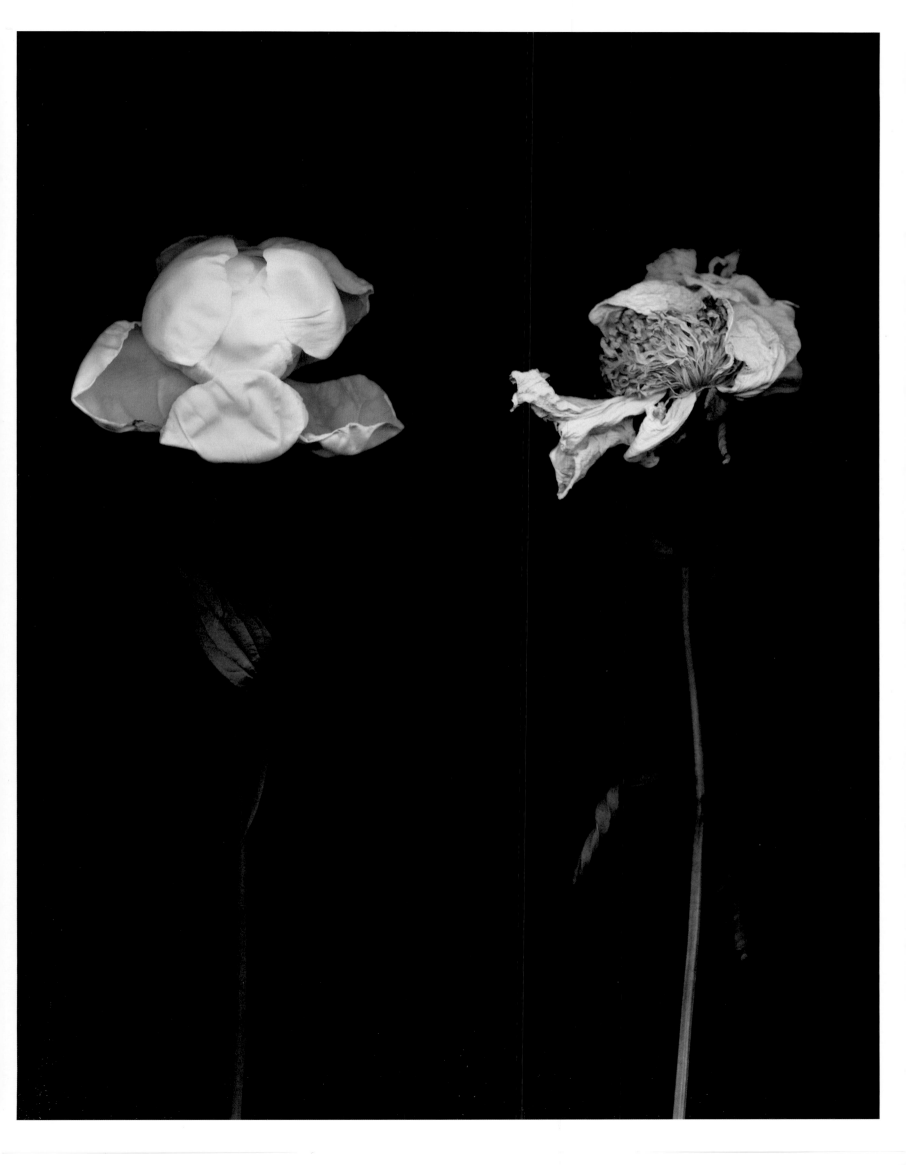

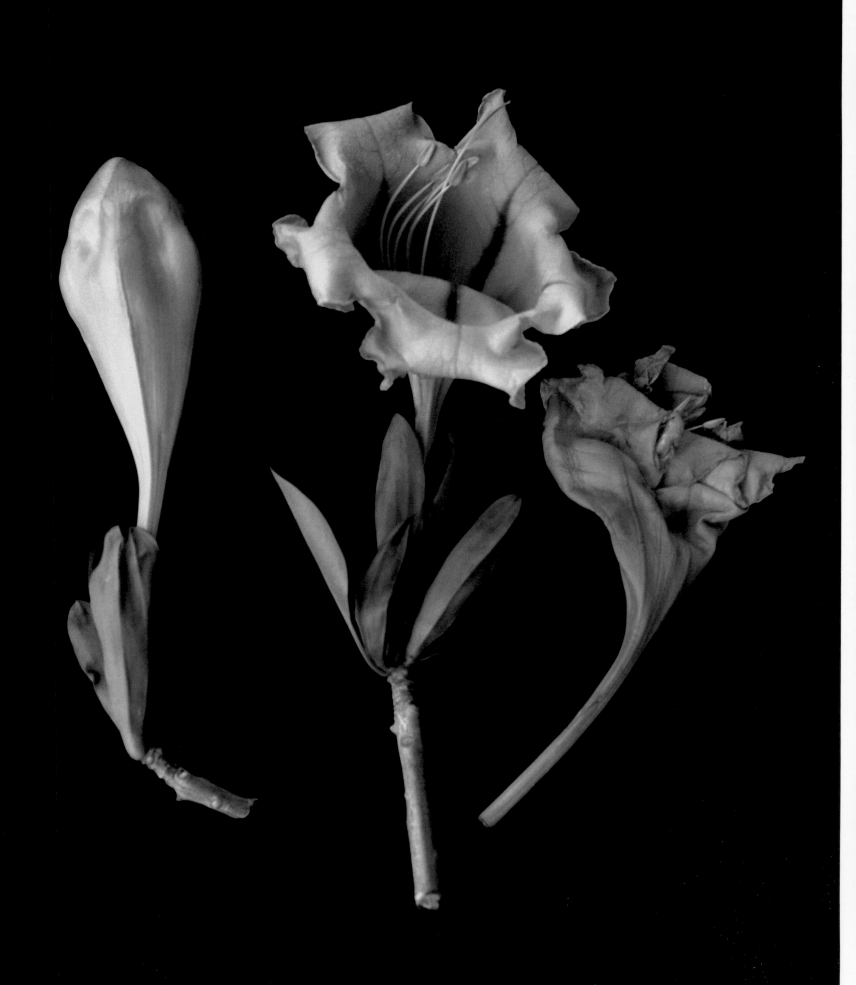

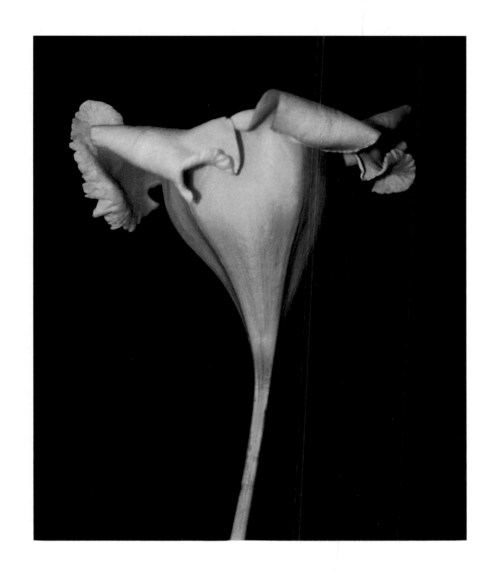

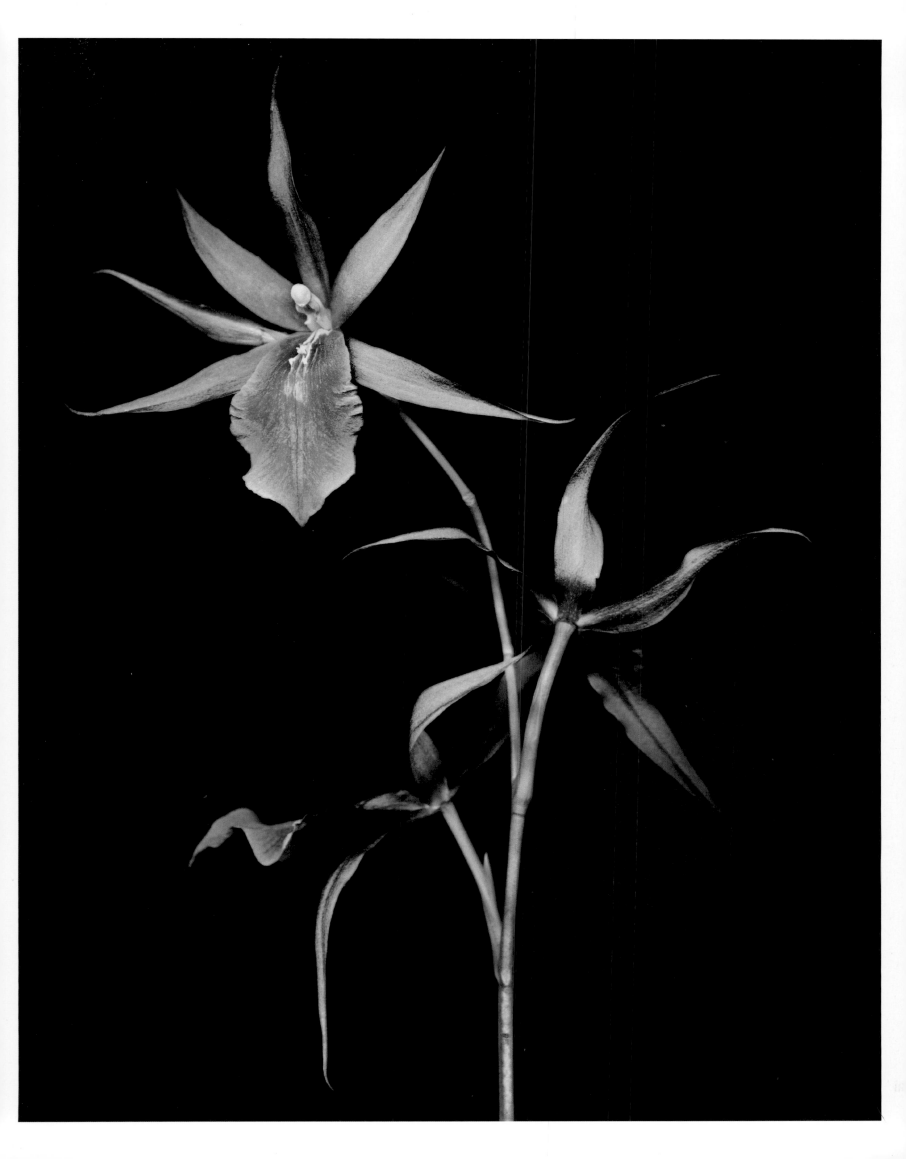

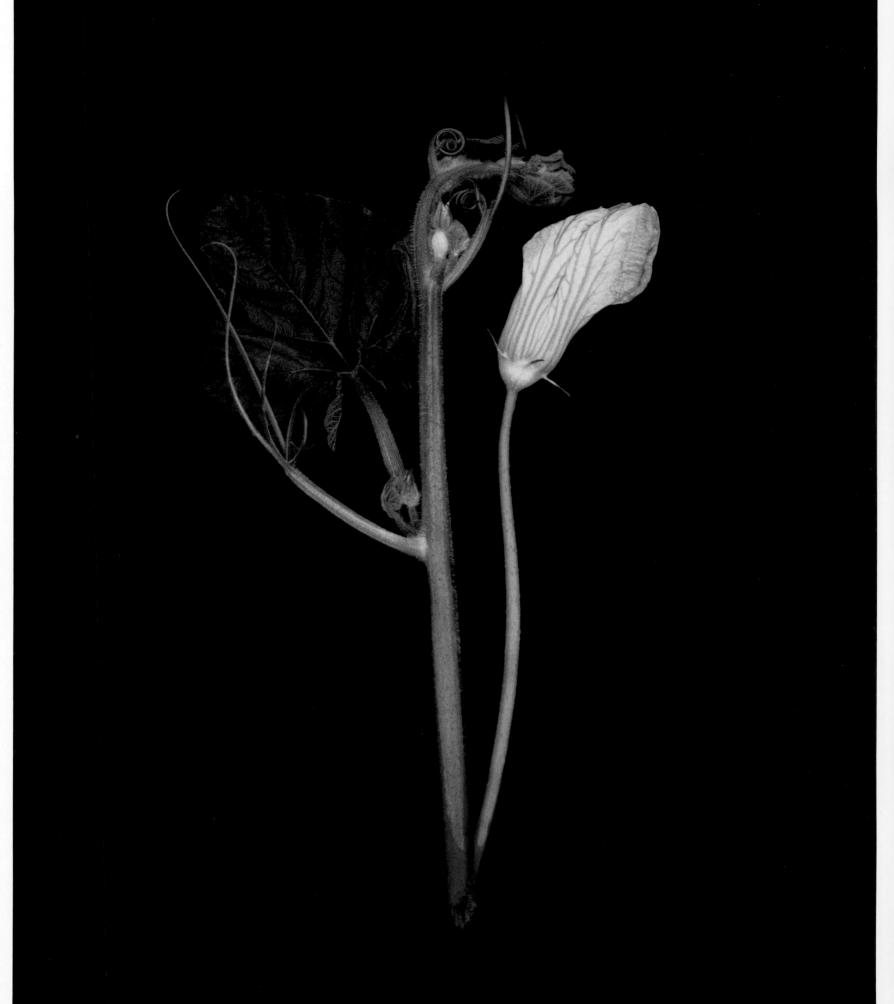

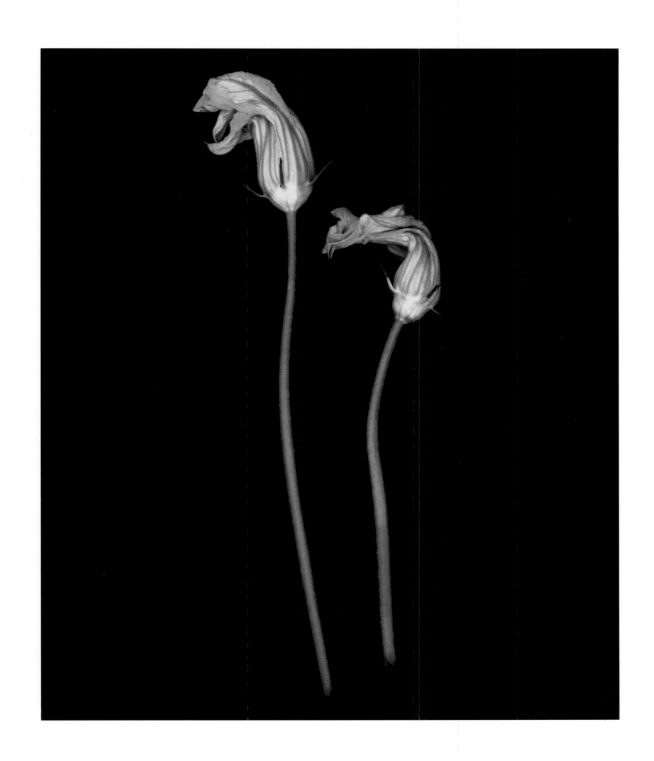

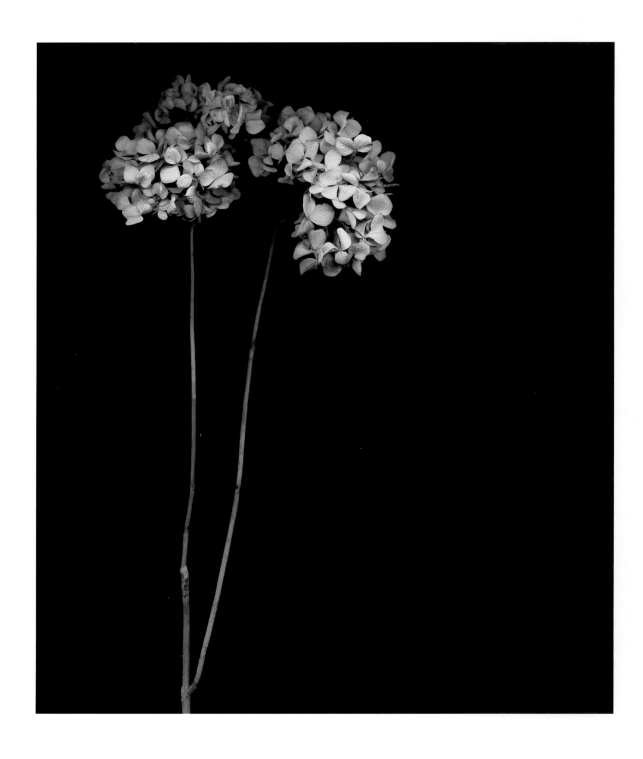

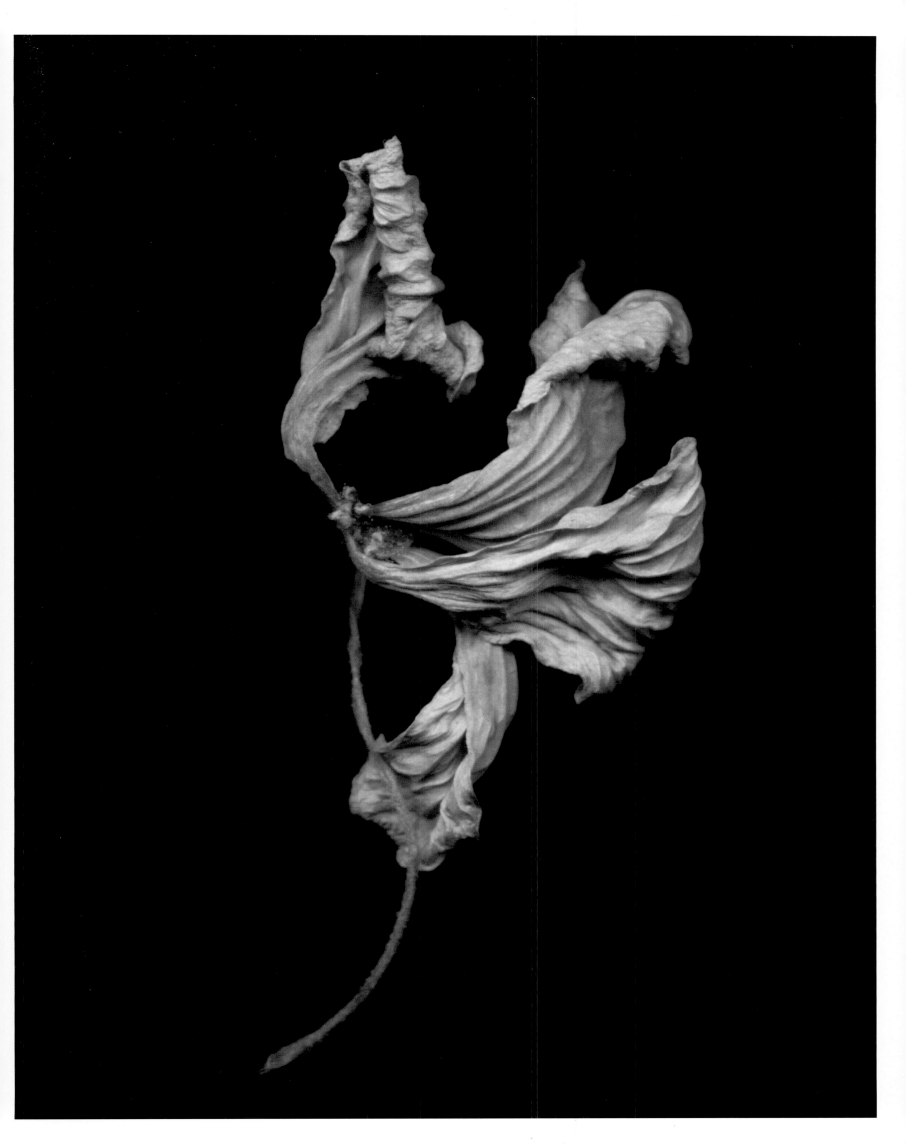

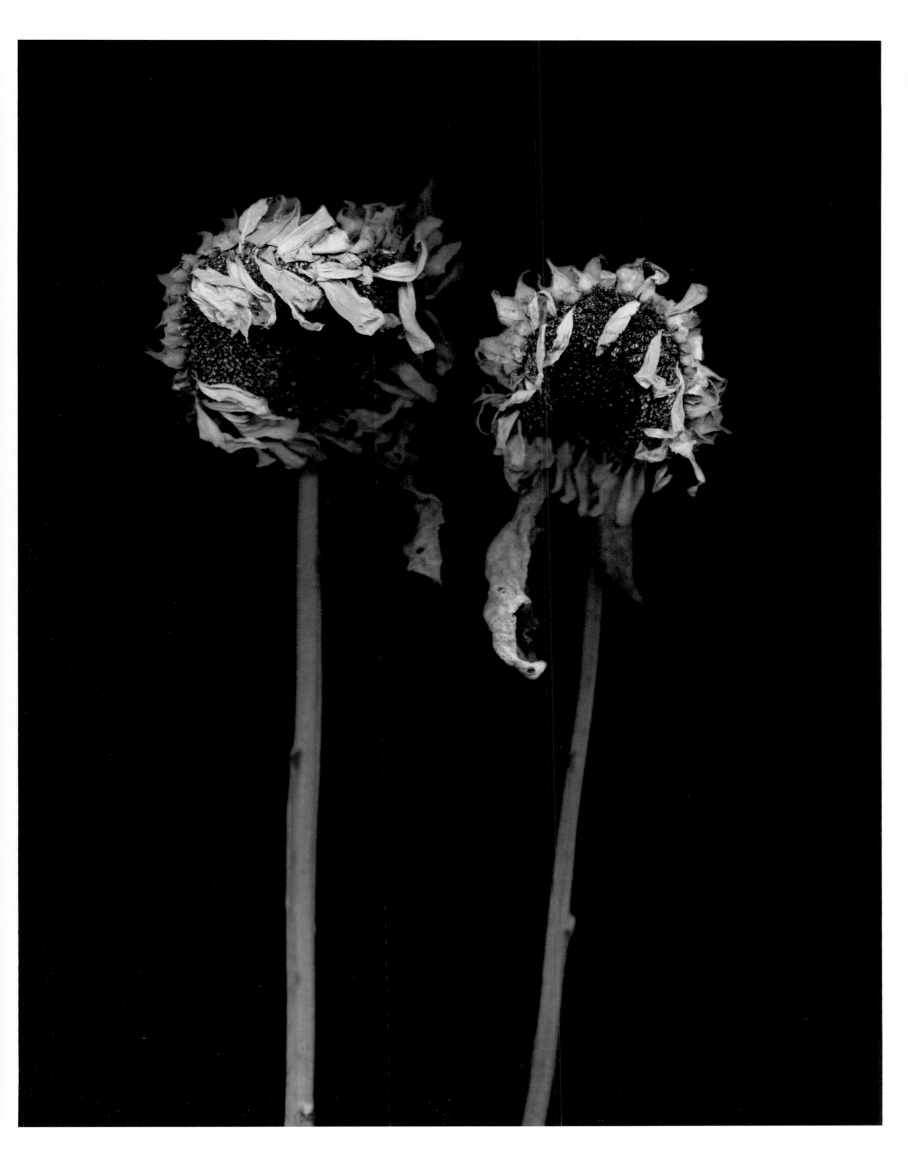

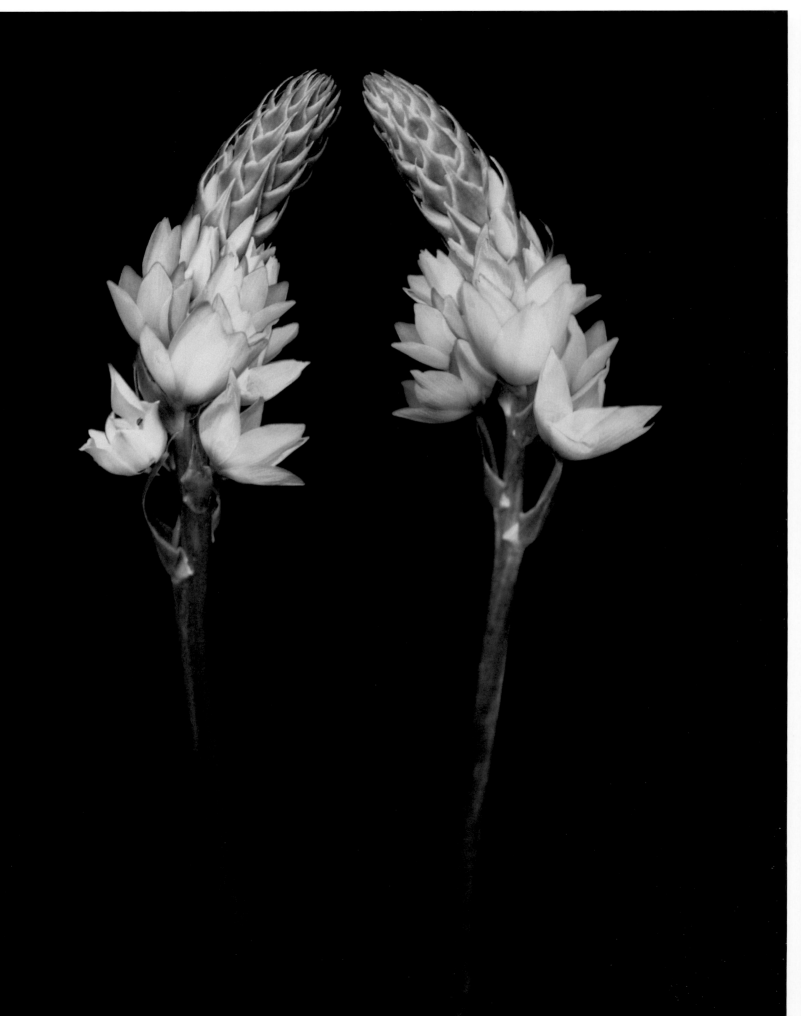

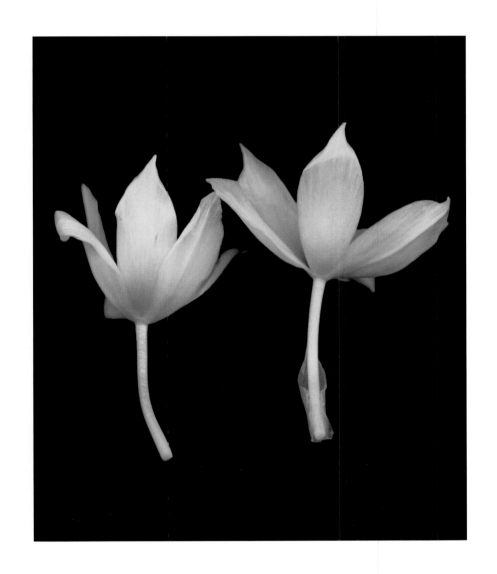

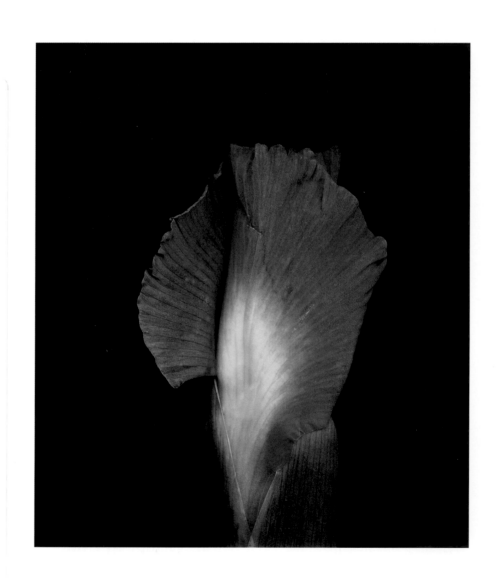

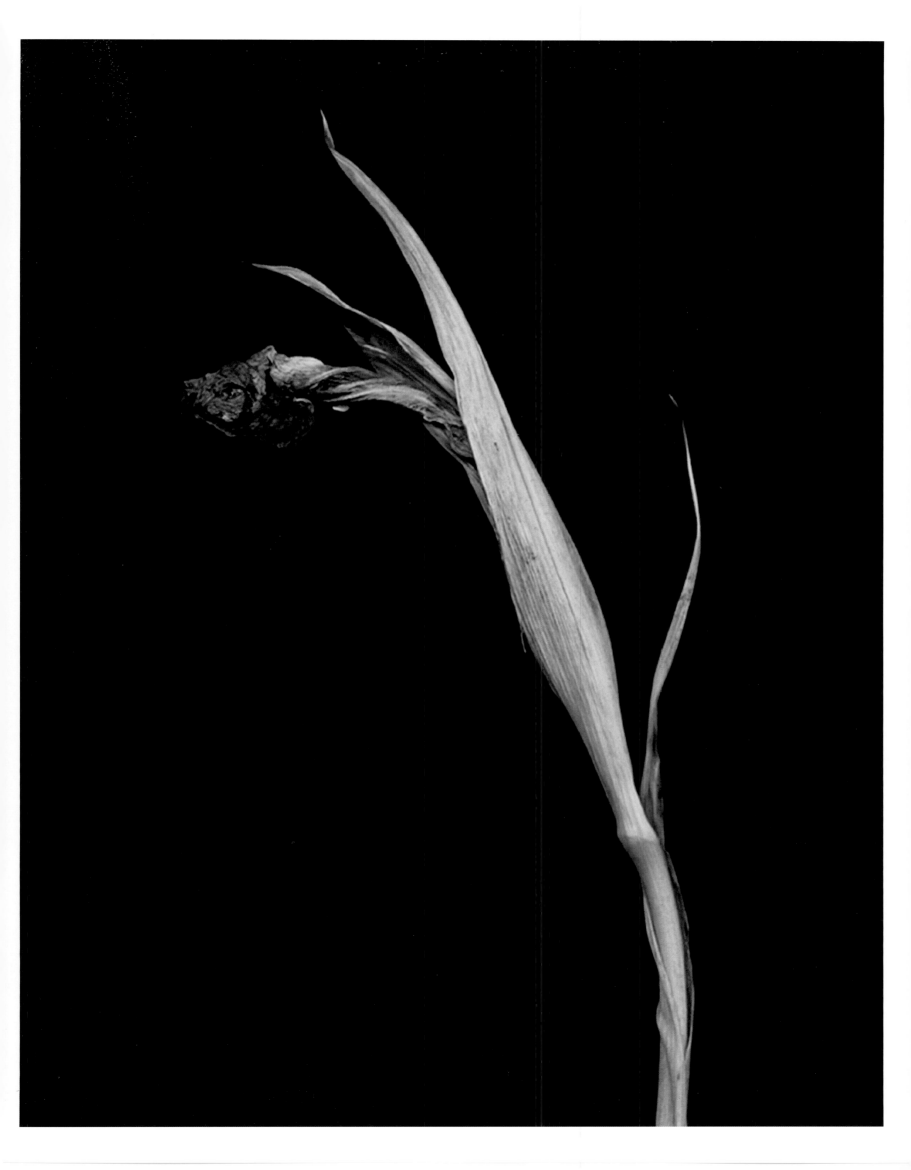

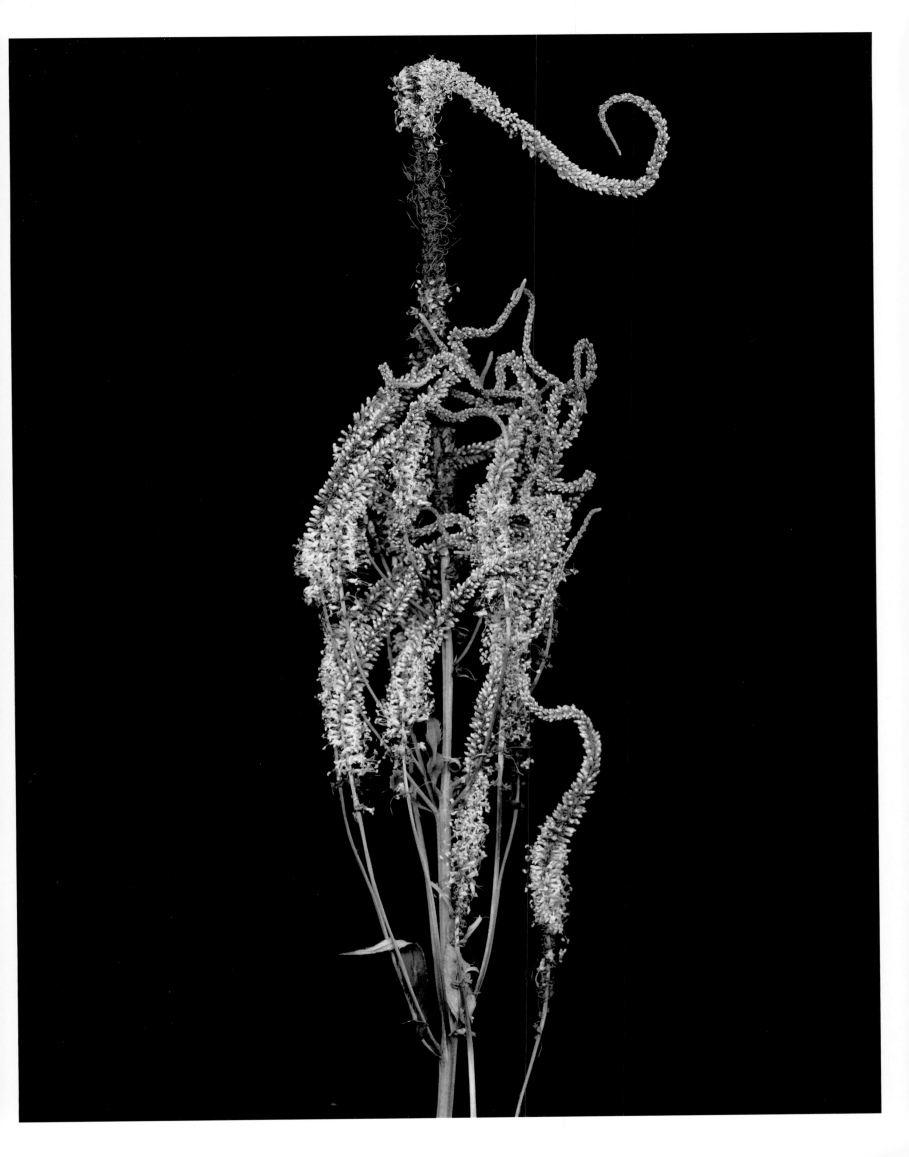

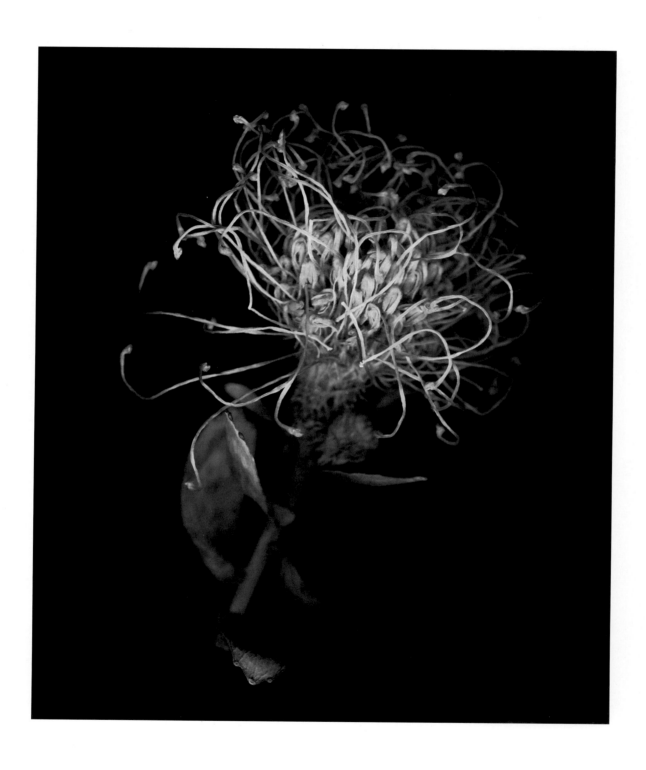

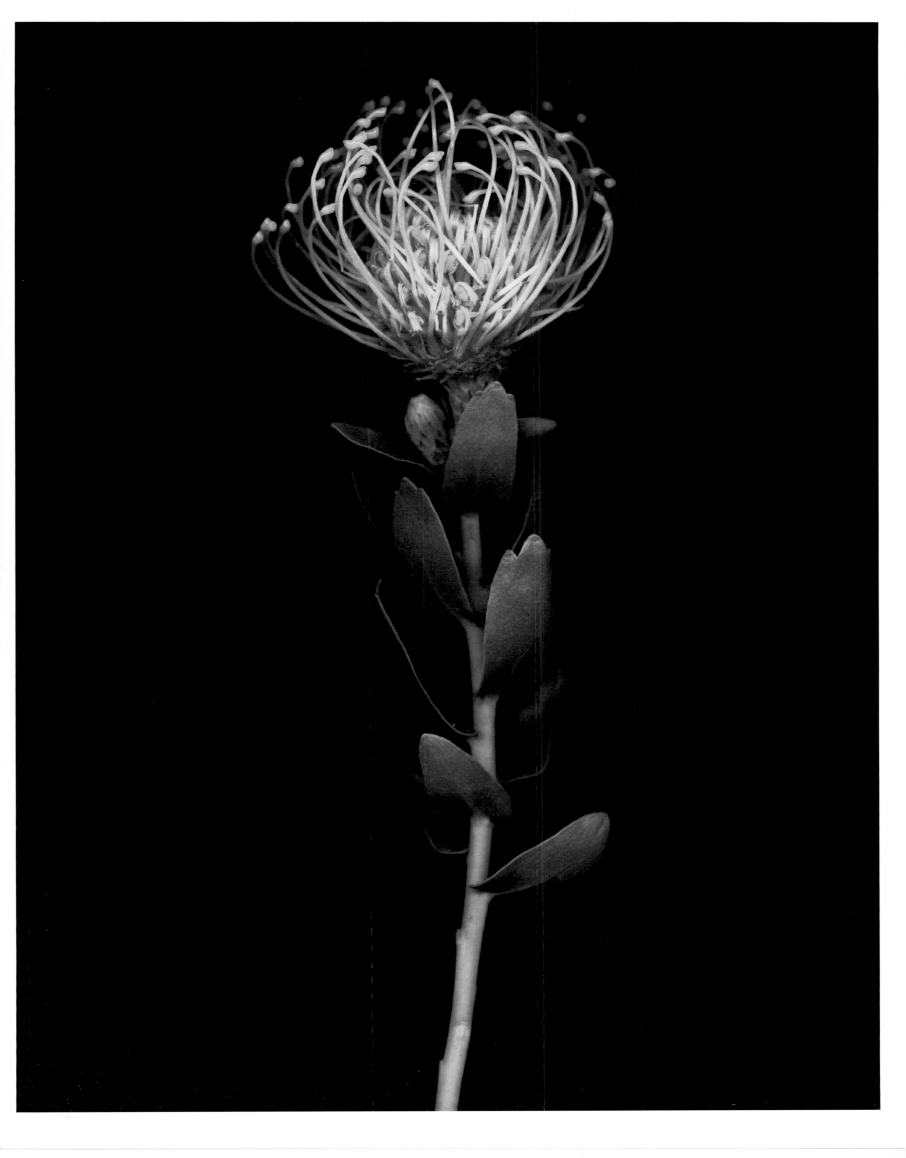

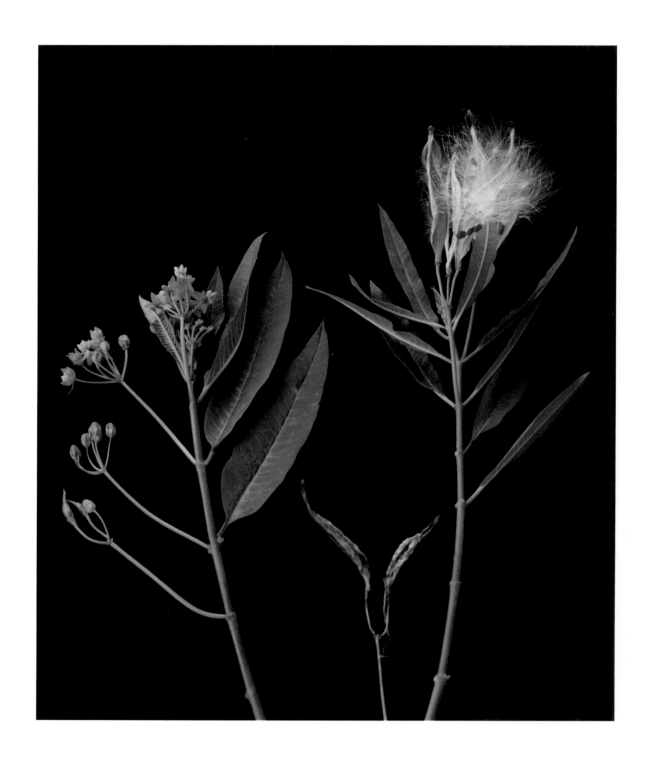

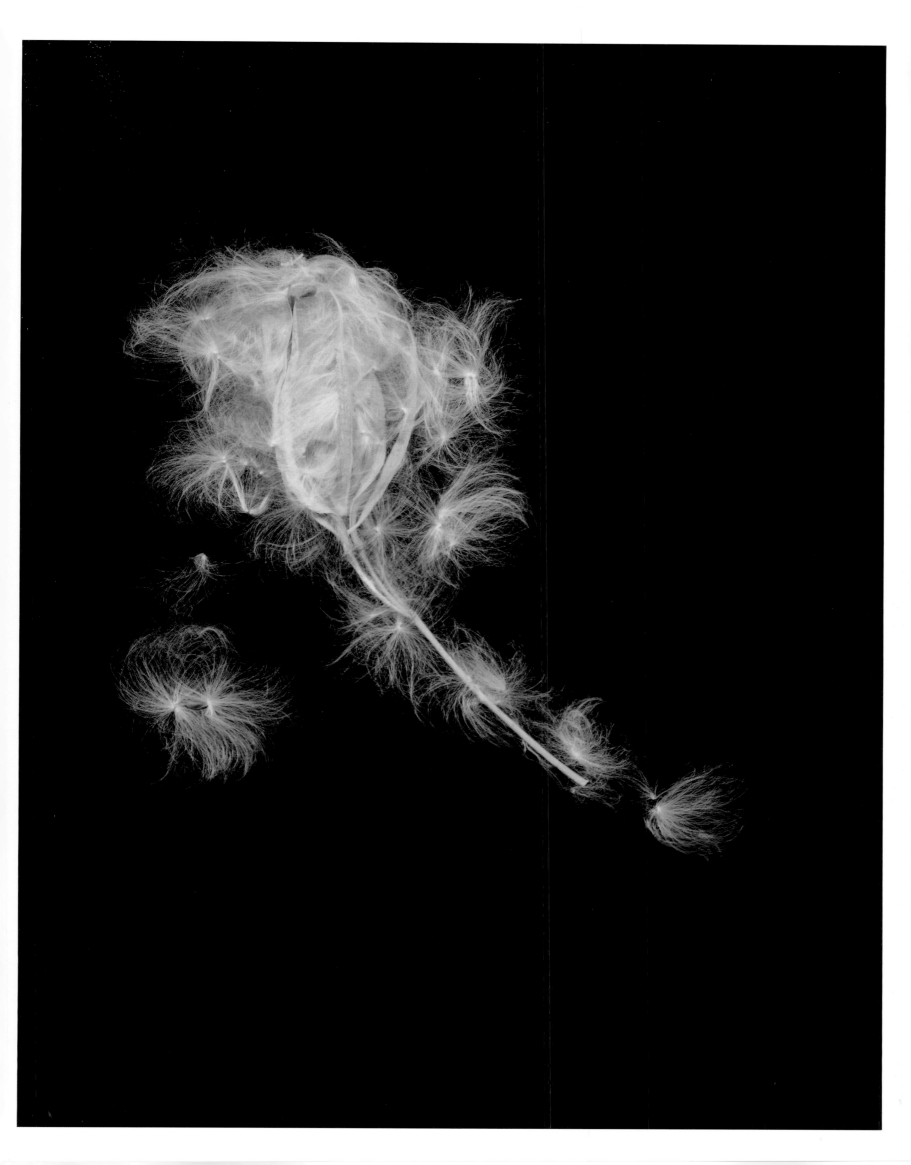

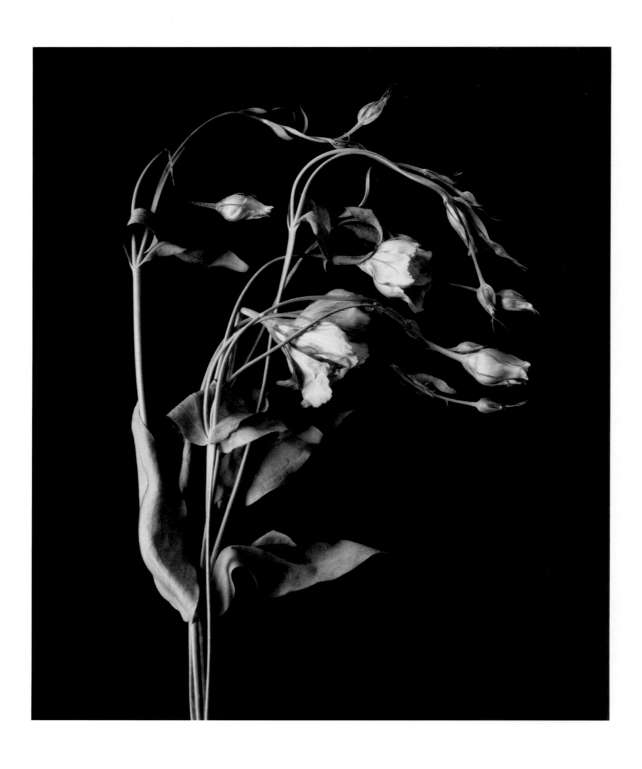

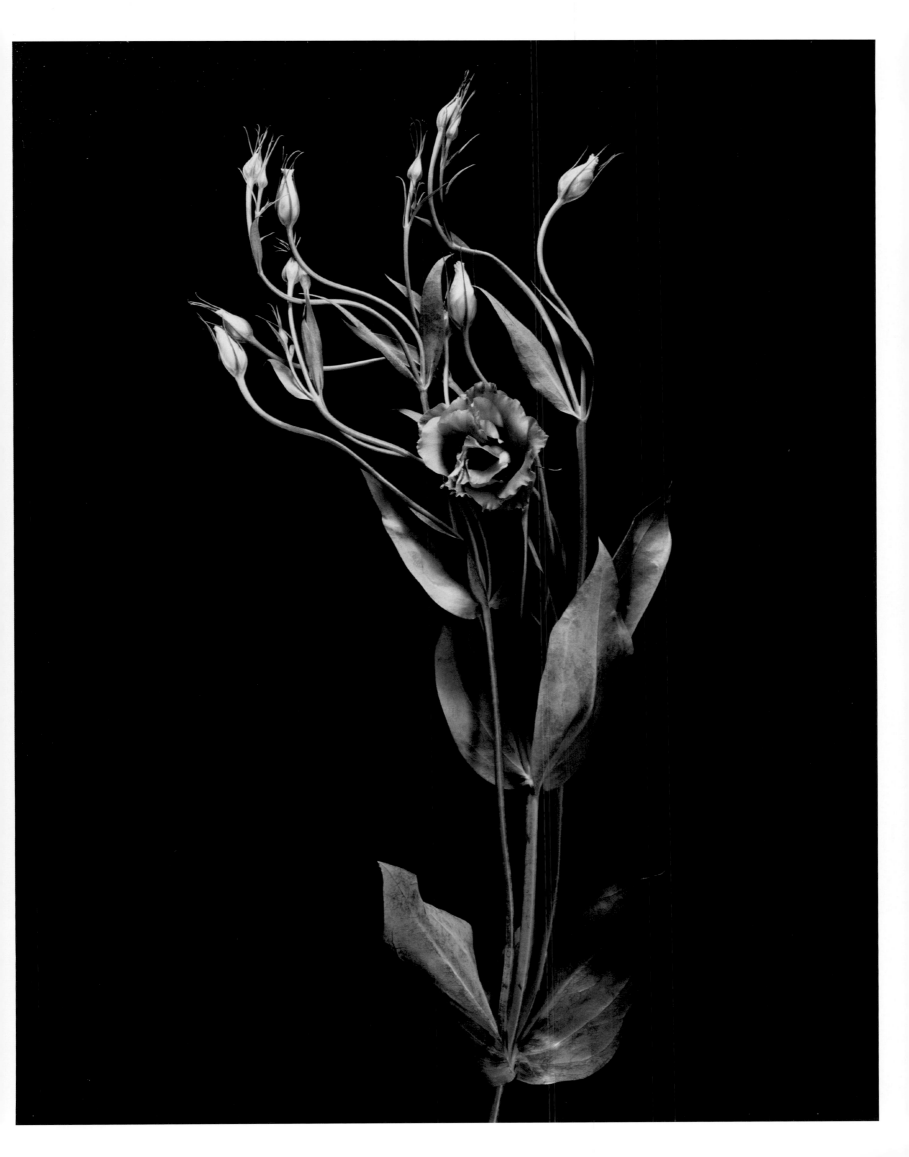

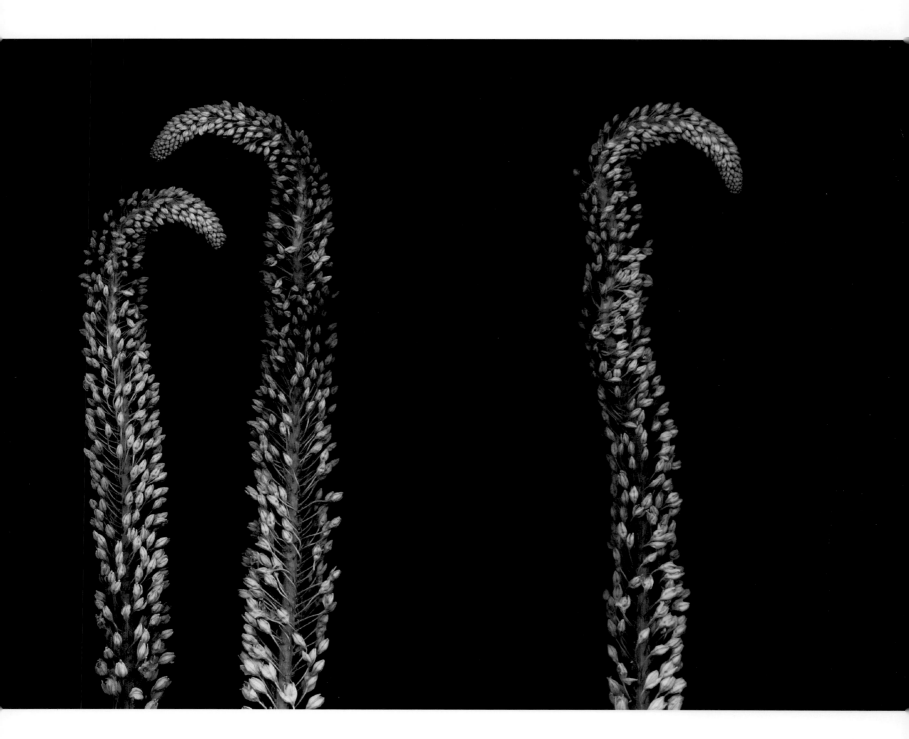

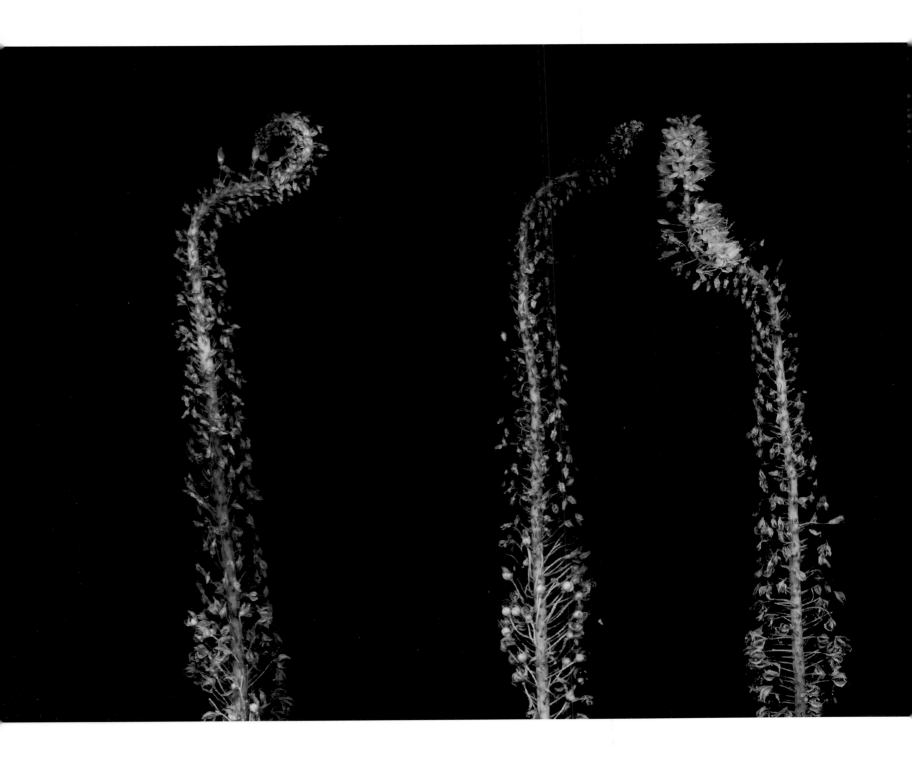

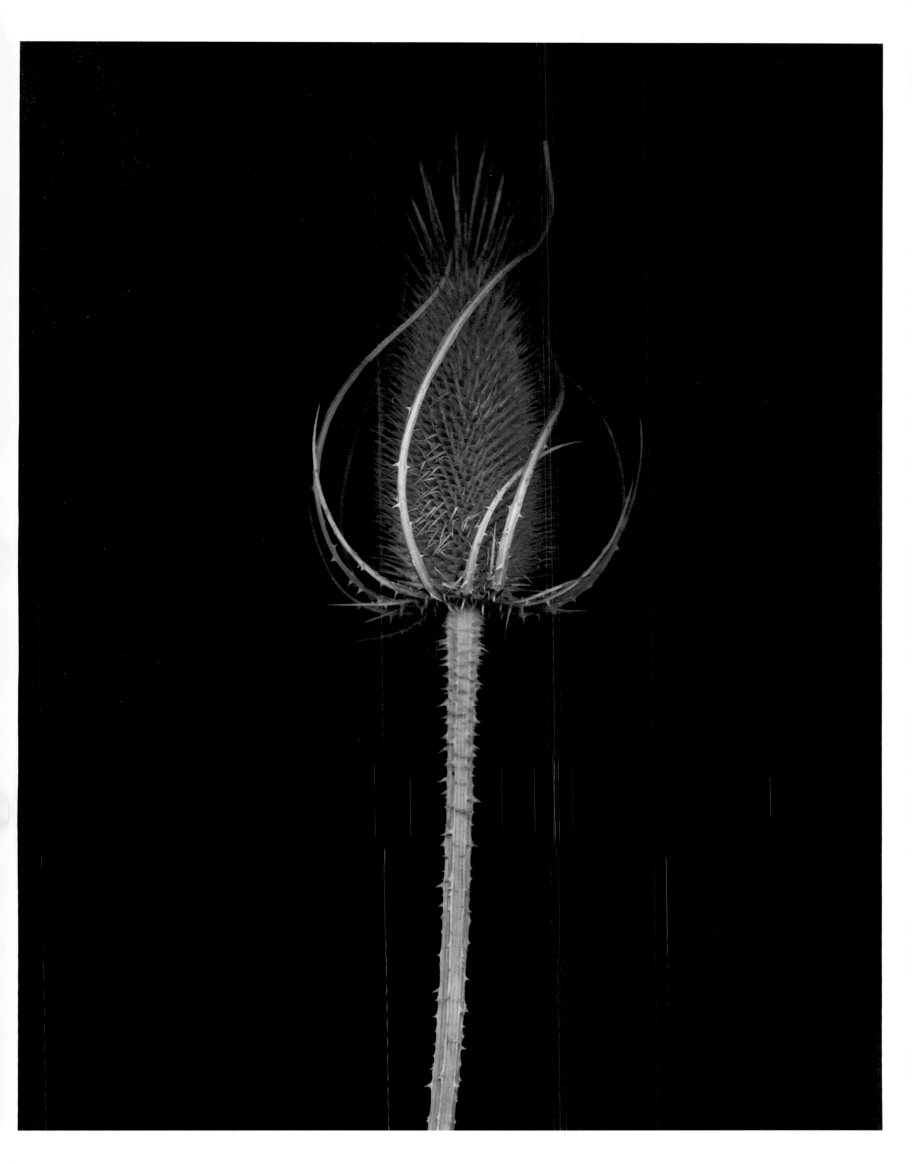

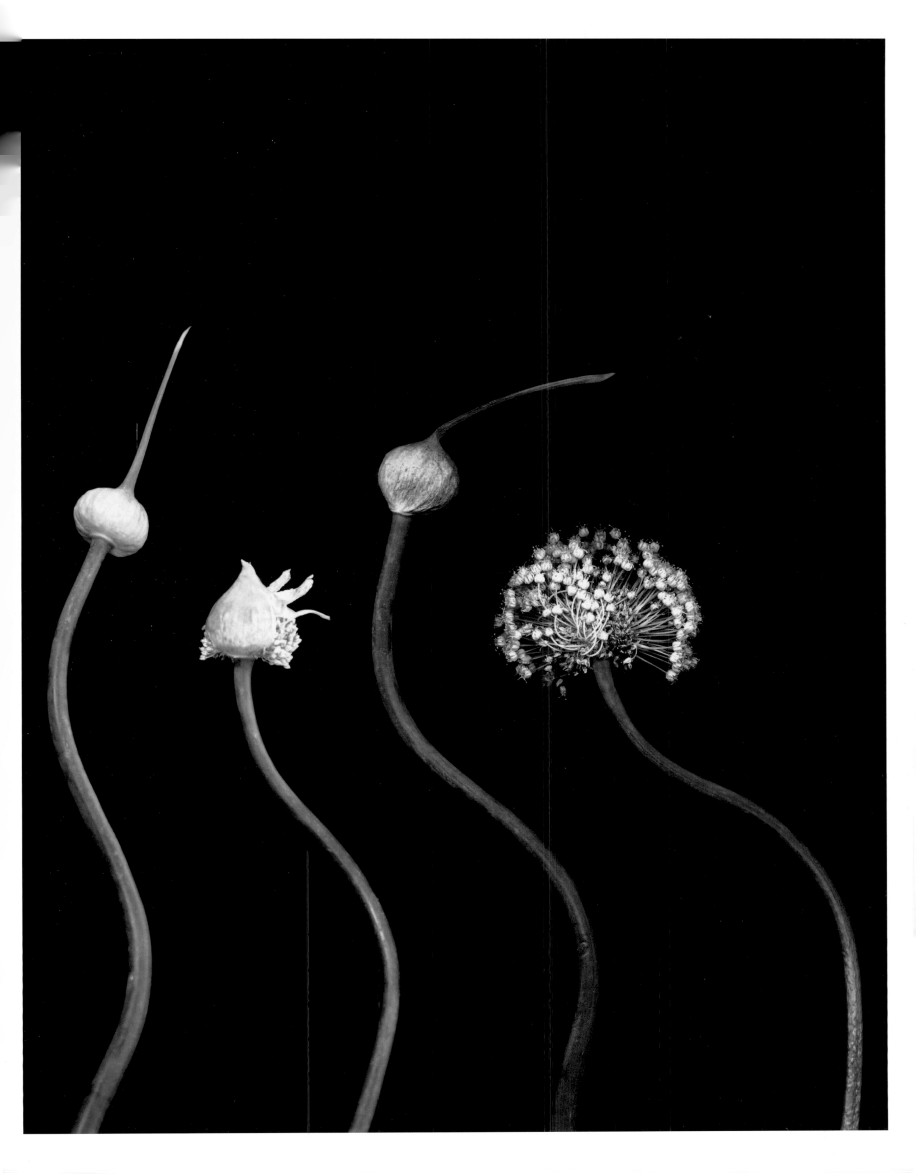

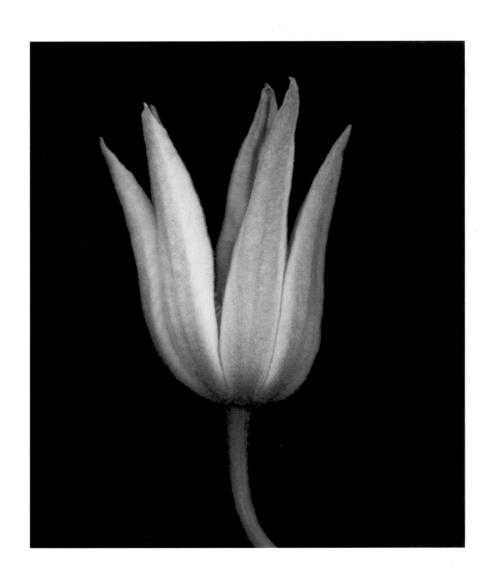

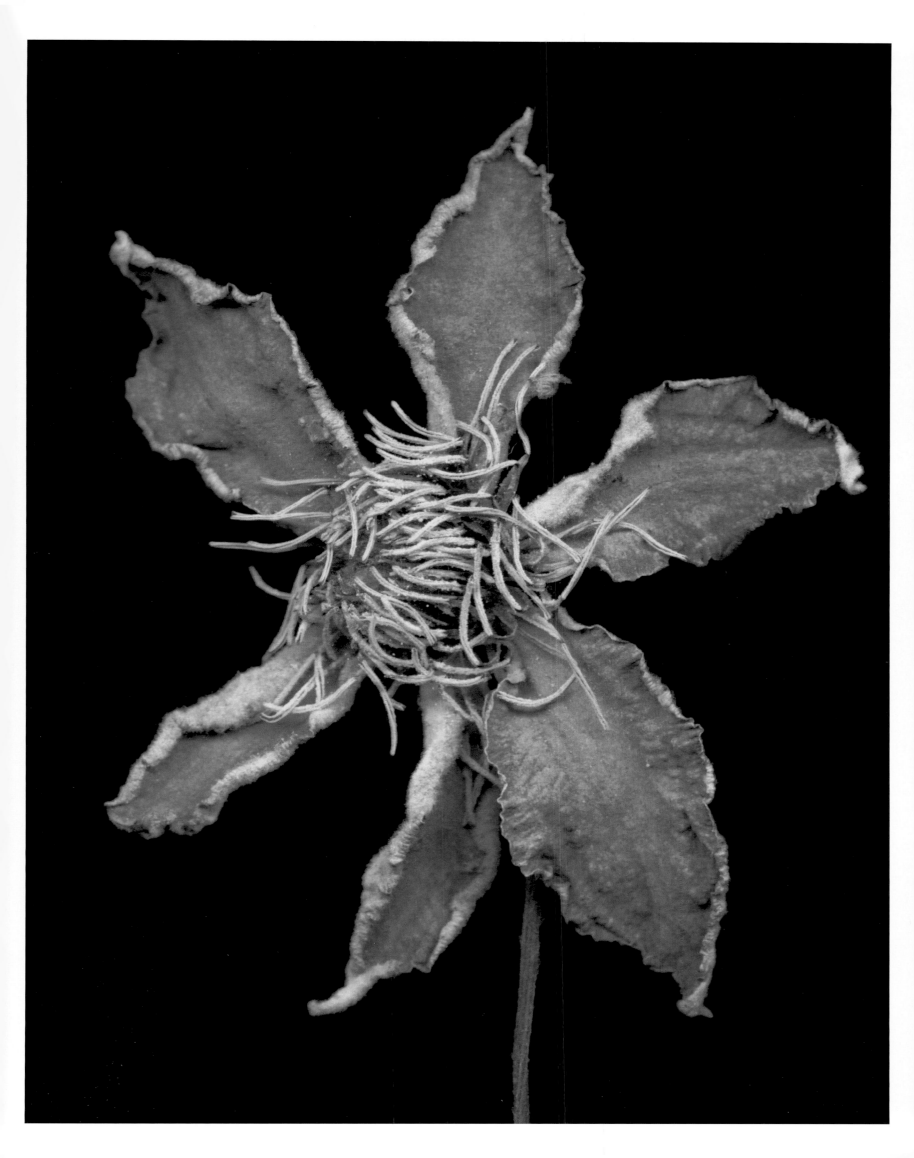

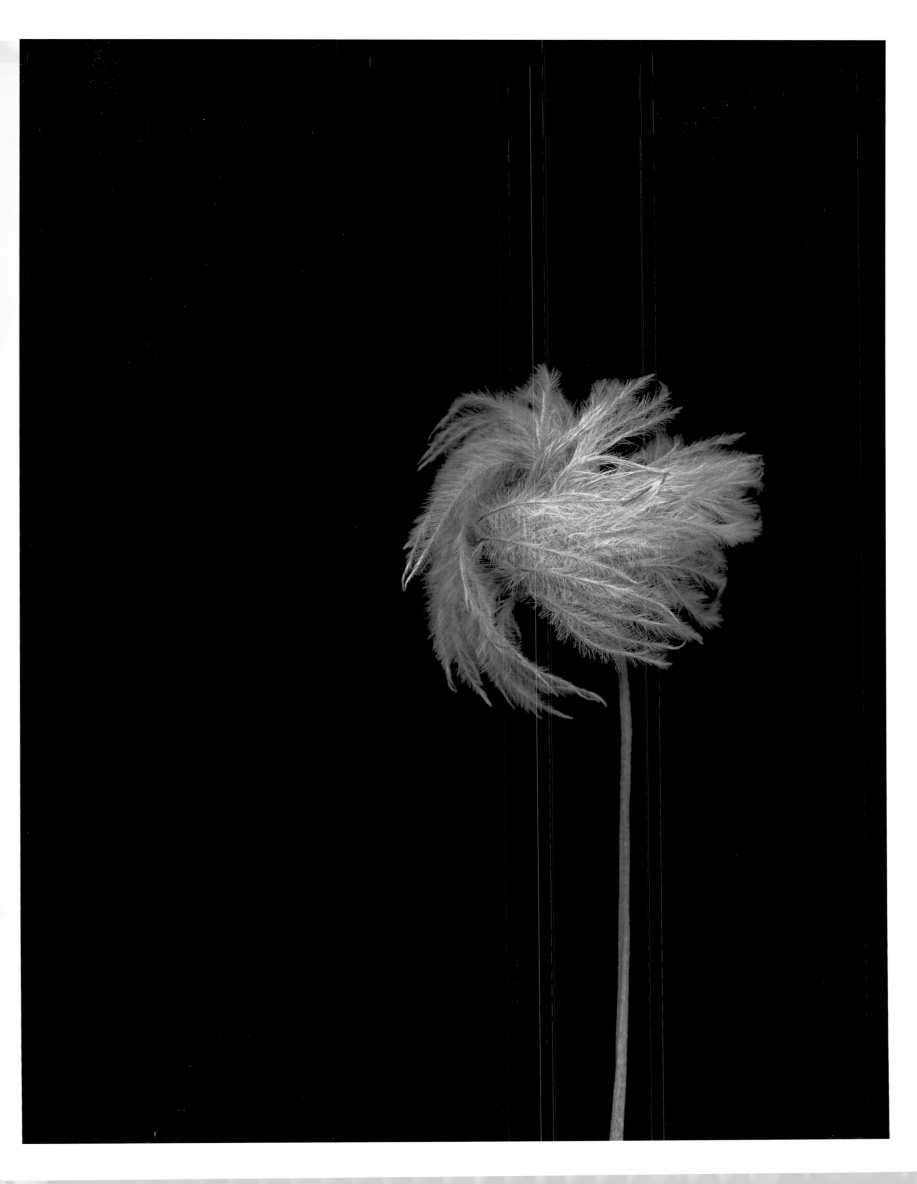

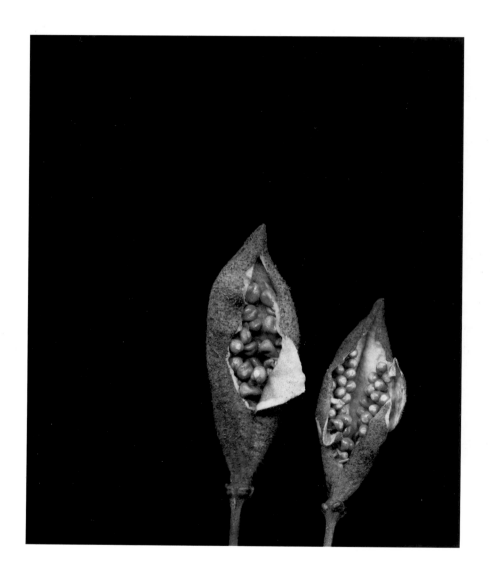

ACKNOWLEDGMENTS

This book has been a labor of love for me. I would like to thank and acknowledge my talented and dedicated assistants, friends, family, and sponsors. I could not have completed *Flower Portraits* without them.

Thank you to:
Avena Botanicals, Camden, Maine, for allowing me to photograph in their gardens. Nick Cassandra, Associated Cut Flowers, New York City, and Kim Wise for helping me with the final identification of some of the exotic and mysterious flowers. Steve and Helaine Huyler, for allowing me to photograph in their private garden. Dan Steinhardt, Epson America, for helping to sponsor the exhibition prints. Mike Newler and Dave Metz, Canon U.S.A., for their continued support of all of my work and lectures. Mark Duhaime, Imacon, Inc., for use of their scanner. Mark Rezzonico, Leaf America, and Jan Lederman, Mamiya, for introducing me to their new medium-format technology.

I am gifted with the assistance of the following photographers who have worked so hard on this project. They are all part of a family of creative young artists who surround me daily:
Lisa Devlin, Miwa Nishio, Christina Richards, Mitch Soileau

To my interns who were also part of our team:
Katherine Barthelme, Ronnie Beach, Amy Boles, Angie Capano, Sara Glazer, Stacey Haines, Wendy Hill, Brooke Mayo, Bandi Ramana, Leila Tauil, Alan Thornton, Brooke Wenth

The wonderful staff at Bulfinch Press:
Matthew Ballast, Jill Cohen, Adrienne Moucheraud, Karen Murgolo, Margaret Pai, Michael L. Sand, Pamela Schechter, Jared Silverman

Friends:
Dan Bereskin, Isisara Bey, Reid Callanan, John Paul and Alex Caponigro, Kate Chaikin, Betsy and Ed Cohen, Marcy Cohen, Ann Currie, Kathy Doyle, Ben Fraser, Fay Gold, Elizabeth Greenberg, Saskia Hamilton, Clymenza Hawkins, Bill Hunt, Patricia Luchsinger, John Reuter, Sao, Elise Wiarda

Also a big thank you to my family — Alex and Kate Cohen, David, Jo, Jessie, and Margaret Jones, Aida Algosaibi Jones, and Anne and Jack Doyle, who had to put up with my consuming passion for this project, which often meant long hours that cut into my time with them.

In addition our research on flowers was greatly aided by many Internet sites, in particular www.botany.com and www.bulb.com. The books *100 Flowers and How They Got Their Names* by Diana Wells and *Botanica's Gardening Encyclopedia* were also invaluable.

And finally, my thanks to the Invisible Presence that provided me these moments of grace.